EXHIBITING GENDER

Sarah Hyde

MANCHESTER
UNIVERSITY PRESS

MANCHESTER UNIVERSITY PRESS Manchester and New York

distributed exclusively in the USA by St. Martin's Press

Published by Manchester University Press
Oxford Road, Manchester M13 9NR, UK
and Room 400, 175 Fifth Avenue, New York, NY 10010, USA

Distributed exclusively in the USA by
St. Martin's Press, Inc., 175 Fifth Avenue, New York,
NY 10010, USA

Distributed exclusively in Canada by
UBC Press, University of British Columbia,
6344 Memorial Road, Vancouver, BC, Canada V6T 1Z2

British Library Cataloguing-in-Publication Data
A catalogue record is available from the British Library

Library of Congress Cataloging-in-Publication Data
applied for

ISBN 0 7190 4242 9 hardback
ISBN 0 7190 4243 7 paperback

First published 1997

01 00 99 98 97 10 9 8 7 6 5 4 3 2 1

Photographs

All the works illustrated in this book
are reproduced courtesy of

The Whitworth Art Gallery
University of Manchester

except

Pregnant Self Portrait, which is reproduced
courtesy of Ghislaine Howard

One with Another, reproduced courtesy of
Cecile Elstein

David's Pool at Night, reproduced courtesy
of Howard Hodgkin

Designed in Aldus and Frutiger
by Max Nettleton FCSD

Typeset by Koinonia Limited, Manchester

Printed in Great Britain
by Bell & Bain Limited, Glasgow

For Alice and Jonathan

Contents

Acknowledgements

LIKE ANYONE attempting to write about such a wide range of objects, my first debt is to the large number of authors on whose researches I have drawn for information about works in the Whitworth's collections; in addition I am especially indebted to those feminist historians whose writings both stimulated my interest in gender issues and helped me to form a framework within which to discuss them.

Many friends and colleagues contributed significantly both to the initial *Women and Men* exhibition and to the subsequent production of this book; I am thinking especially of my former colleagues at the Whitworth Art Gallery: Jennifer Harris, Frances Pritchard, Ann Tullo and Christine Woods, who were unfailingly supportive of my reckless attempts to tackle huge areas of textile and design history; Charles Nugent and Michael Simpson who also shared their specialist knowledge with me; Frances Bowers, Tracey Jones and Janet Nelson, Frances for dealing with the endless complications of my photographic requests, and Peter Burton and Michael Pollard who photographed all the objects illustrated here. My greatest debt, however, is to my former colleague Greg Smith, who supported the idea of the exhibition project from the outset, and with whom I have continued to discuss the issues involved, and on whose researches and ideas I have continued to draw, ever since. Having left the Whitworth before being able to begin the writing of this book, I am very grateful to my new director, John Murdoch, of the Courtauld Gallery, for allowing me to devote the necessary time to its completion, and for his continued support in other ways.

During the course of the number of years I have been working on this project I have discussed the ideas involved with many people; conversations with Caroline Bennett, Bill Bradford, Mary Brooks, Deborah Cherry, Diana Donald, Anna Douglas, Belinda Harding, John Murdoch, Lynda Nead, David Phillips, Marcia Pointon, Liz Prettejohn, Melanie Roberts, Katie Scott and Andrew Stephenson have been especially stimulating and informative. Deborah Cherry and Greg Smith have also read, and made many helpful comments on, earlier drafts of this book. I am also grateful to the numerous people, including staff and sixth form pupils at Turton High School in Bolton, who gave up their time to come into the Whitworth Art Gallery prior to the hanging of the *Women and Men* exhibition and discuss their responses to potential exhibits with me; their enthusiasm and interest gave me the confidence to go ahead with the project. Thanks also go to those contemporary artists whose work was shown in the exhibition as well as those illustrated in this book – Cecile Elstein, Kip Gresham, Howard Hodgkin, Ghislaine Howard – for their willingness to support this unconventional way of approaching their work. Katherine Reeve at Manchester University Press greatly heartened me by her initial enthusiasm for my book proposal, and Vanessa Graham carried the project through with energy and determination.

Last but not least … heartfelt thanks to Jonathan Bennett and Alice Hyde who have encouraged and supported me as I devoted so much time to this book when I should have been doing many other things.

Introduction

THIS BOOK developed out of an exhibition called *Women and Men,* held at Manchester University's Whitworth Art Gallery between December 1991 and August 1992. The main aim of the exhibition was to provide visitors with a means of engaging actively with the works on display. This was done by showing about fifty works from the Gallery's collections in unlabelled pairs, consisting of one work by a woman and one by a man. Each pair was accompanied by a label asking 'Which is the woman's work?'. Visitors were thus asked to examine carefully not only the works on display, but also their own responses to them, in particular the ideas they had about the way in which an artist's gender might or might not affect their work. Having done this they could then lift a flap which both revealed the answer and provided those interested with a further discussion of the complex issues raised.

The exhibition's success was demonstrated by the unusually extended amount of time which visitors spent in the exhibition itself and in studying individual exhibits, as well as by enthusiastic comments left in the comments book, such as 'What a wonderful surprise to see and TAKE PART IN this exhibition' and 'A revealing and innovative way of making us look at art.' (*Women and Men Comments Book,* 1991). The decision to use the exhibition

as a basis for a book was prompted by the number of school teachers and university lecturers who brought parties of students to the exhibition, and said they found it a particularly useful stimulus for the discussion of gender issues both in the gallery and back in the classroom. One of the aims of this book, therefore, is to provide teachers with a way of introducing gender issues to their students which is both stimulating and fun. The book is not aimed at specialist readers; anyone who can immediately identify the producers of the works illustrated here will find it difficult to suspend this knowledge whilst examining their assumptions about the gender of the producer. Instead, the book offers readers who do not consider themselves particularly knowledgeable about 'art' a way of studying and thinking about individual works, on their own or with a companion, which builds on, rather than ignores or negates, their own responses to these images.

The book does, nevertheless, differ in many ways from the exhibition. Over half the pairs of objects illustrated here were not exhibited at the Whitworth, although all of the works have been selected from the Gallery's permanent collections. The advantages of producing a book which is not merely a record or a catalogue of the exhibition is that is makes it possible to include works which, either for conservation reasons, or because they were committed for loan elsewhere, could not be

included in the exhibition, and to juxtapose works which, because of their size, weight or shape, were difficult to put together in the Gallery. Nevertheless, the decision to limit the selection of objects illustrated here to works owned by an English provincial gallery is worth discussing further, since it introduces a number of important considerations connected with the study of art history in general and with the study of gender issues in particular.

Collecting art at the Whitworth

Since the pairs of works discussed here have all been selected from the objects owned by the Whitworth Art Gallery, the particular character of the Gallery's collections, its emphasis on certain kinds of object rather than others, is inevitably reflected in this book. It is thus important from the outset to understand how and why these emphases developed. The Whitworth was founded, just over a century ago, with money left by the engineer Sir Joseph Whitworth, but the Gallery and its collections were shaped not by him but by a committee of Manchester men, who intended to establish an institution which would provide

a permanent influence of the highest character in the directions of Commercial and Technical Instruction and the cultivation of taste and knowledge of the Fine Arts of Painting, Sculpture and Architecture. (Whitworth Art Gallery 1989:3)

However, these initial, expansive intentions were eventually narrowed to produce an art gallery focused on a small number of areas of collecting, primarily textiles, watercolours and prints. In most cases the choice of these areas was influenced by the possibility of acquiring, through purchase or bequest, pre-existing collections formed by wealthy and influential men. The governors' intention to form a collection of textiles which would stimulate and inspire the textile industry in and around Manchester led to the purchase, in 1891, of a collection built up by Sir John Charles Robinson, ex-Superintendant of the collections at the South Kensington (now Victoria and Albert) Museum. The collecting of British watercolours focused around a selection from his own collection donated in 1891–93 by John Edward Taylor, the proprietor of the *Manchester Guardian*; and the collecting of prints, undertaken sporadically in the early days of the Gallery, was firmly established with a bequest from G. T. Clough in 1921. Although the Gallery had collected individual pieces of contemporary art since its opening, it was not until the 1960s that a more coherent policy of establishing a 'modern art collection' was formulated; this consisted mostly of contemporary British oil paintings and sculpture. The most recently established collection, that of wallpapers, also began during the 1960s, with an archive collection given by the Wall Paper Manufacturers Ltd.

Selecting from the Whitworth's collections

Since they were selected entirely from the collections developed in the manner described above, the pairs of objects discussed this book consist mainly of textiles, prints, wallpapers, watercolours and twentieth-century British art. There are no photographs, no metalwork, only three pieces of sculpture and, especially surprising for many people, only one oil painting. Like the Gallery's collections, the majority of the works illustrated here were made in Britain, and most date from the nineteenth and twentieth centuries; there is only one object made outside Europe, and no objects produced before the seventeenth century. Although there is a better balance between objects usually labelled 'fine art' and 'craft', there are still whole areas of production – glass and furniture, portraiture, history painting and metalwork – which are entirely absent. However, the decision to continue to use the Whitworth's collection as a basis for the book was made for two important reasons. One was that the character of the collections is in some ways typical of many British provincial galleries, so that any individual or teacher wanting to do so might find it possible to apply this format to the collections of their local art gallery. The second, and more important, reason was that one of the themes of this book is the way in which our ideas about gender and art have been affected by the way in which British art galleries have

collected, displayed and interpreted both art by women and representations of women. The character of the Whitworth's collections is therefore not a restriction but an issue in itself which must be investigated. The function of British art galleries, in particular in defining and policing the boundaries between certain categories, such as fine art and craft, or art and pornography, is of fundamental importance to the examination of the gender issues raised here.

However, it might also be necessary here to explain firstly the criteria which guided both the selection of particular objects from the Whitworth's collections, and secondly the way in which they were put together in pairs. To begin with, this book, with one major exception (see p. 26) deliberately does not deal with the best known and most frequently exhibited of the Gallery's objects. Since it is hoped that readers will initially examine the pairs of works illustrated without knowing whether they were produced by men or women, it would have been counter-productive to choose works such as, for example, the Whitworth's watercolours by J. M. W. Turner or textiles by William Morris, which are so widely known that many readers would recognise them immediately. Likewise, the work of certain women artists with exceptionally distinctive and thus immediately recognisable styles, such Ana Maria Pacheco, has reluctantly been excluded. The selection is

therefore deliberately focused on works which are not amongst the most famous of the Gallery's holdings, and includes many which are rarely on show, and some which have never been published before.

Related to this was the decision to focus the selection on the 'decorative' and reprographic arts: on textiles, wallpapers and prints. This is partly, of course, because, in strictly numerical terms, by far the largest number of works by women can be found in the textile collection, whilst, at the time of the *Women and Men* exhibition, the ratio of works by men to those by women in the British drawings collection was 32 to 1. More important than than this, however, was a desire to readjust the focus which, like many provincial art galleries, the Whitworth has often given to the fine art collections at the expense of the 'decorative' arts (with the unspoken but implied adjective 'merely'). It seemed especially important to take the opportunity to analyse the part played by gender in the establishment and maintenance of these hierarchies which have been detrimental to so much work produced by women.

Secondly, a word about the selection of works to be paired together. In some cases two extremely similar works are compared: the first pair in chapter 1 consists of two works made around the same date, in the same medium and in the same style. Most of the

other pairs have several things in common: in many cases they were produced at roughly the same period, in the same country and frequently in the same media. Such juxtapositions are intended to focus the readers' attention on what the works *do not* have in common, so that questions can begin to be asked about whether gender is one of the issues which might account for these differences. In some cases, however, it has seemed more useful to juxtapose works from the same period in different media, or works treating the same subject at different periods, and in one case to look at objects produced in different continents (see p. 27).

Nevertheless, some visitors to the exhibition expressed their concern that they were being manipulated by this structure; that the pairs of objects had been chosen in order to bring up, and then deny, their instinctive responses, for example by deliberately placing a 'feminine' work by a man, such as a small pastel in delicate colours, next to a 'masculine' work by a woman, such as a large, geometric abstract in strident colours. It was certainly true that, in looking through the Whitworth's collections in order to select pairs to be included in both the exhibition and the book, it became clear that for every pair that could be put together to refute stereotypical notions of gender and art production, there was one which would confirm them. I have therefore not included any individual works, or pairs of works, which

either confirm or deny any simplistic notion of the relationship between art and gender. Instead I have paired works which have important things in common; in particular I have for the most part chosen not to juxtapose objects which are too far apart in date, so that as far as possible the reader does not have to take into account vast historical changes when making the comparison. Overall the aim of the exercise has emphatically not been to catch readers out, or even to see whether or not readers get the answer 'right' or 'wrong'; more important is the analysis of the thought processes which lead to their conclusions.

A further point about the pairs structure is that it reflects and emphasises, as well as questions, the whole notion of dichotomy, of binary opposition, which has been fundamental to the way the idea of gender has been mapped on to cultural production in our society. The idea of the two genders as binary opposites has been one of the most important ways in which the 'female' has been registered as 'other', and therefore subordinate. It seems useful to take and use this idea of opposites, so that the very structure of paired opposites is part of the problem under investigation.

Nevertheless, the pairing of works by men and women does serve to emphasise that the question 'Which is the woman's work?' is most appropriate to the production of fine art objects, such as watercolours, where a single

person can be assumed to have carried out, or at least controlled, the production from beginning to end. It is, however, far less appropriate to works produced by two or more people in collaboration, and therefore often made by both women and men. The dominance of the model of the artist as the sole producer of a work of art stems from the overemphasis which most Western art institutions have placed on particular kinds of art works, and in particular on oil paintings. The single producer is in fact the exception rather than the rule in most cultural production; all industrial production, most craft work and even some activities usually categorised as fine art, such as printmaking and sculpture, are collaborative processes. One of the issues I particularly want to investigate here is the way in which the different roles incorporated into these collaborations – often a division between designer and executor – have been divided between men and women. A closely related issue concerns the many ways in which art galleries like the Whitworth can misrepresent the wide variety of ways in which cultural products can be made. It is also for this reason that the bald question 'Which is the woman's work?' asked in the exhibition has been supplemented by a short description which makes clear which aspect of the production processes is being compared.

Art galleries and the issue of gender

Some of the responses to the exhibition, both from the press and the public, made it clear that many people remained to be convinced that gender *was* an issue which needed to be considered in an art gallery. Amongst the majority of enthusiastic responses in the comments books was an insistent minority answering the question 'Which work was produced by a woman?' with another question: 'Does it matter?'. The feelings prompting this questioning ranged from the dismissive response of the male art critic of the local evening paper, who felt that the title *Women and Men* must have been devised 'either by a feminist or a new man' (Robert-Blunn 1991:32), to the more thoughtful position taken by the female owner of a West End gallery, who felt that 'If gender is the only thing that can lure people into studying a painting it is rather depressing. It may be traditional to assume that men's art is different from women's, but I am not convinced. I want to show good art, and gender doesn't come into that.' (Maureen Paley in Thomson 1991). The aim of the exhibition, however, was not to convince visitors that art by women does or does not differ from art by men; that was left up to individual visitors, who came away with quite different ideas about whether they could or could not tell the difference. Rather, I hoped the exhibition would convince visitors that the answer to the question 'Does it matter?' was emphatically 'Yes'. It may, therefore, be useful at this point to examine some of the important reasons why the issue of gender should be considered in the context of an art gallery.

The most obvious reason is that some artists have taken their experiences as a gendered being as the subject matter of their work, so that any engagement with their art demands an engagement with the question of gender. Sue Arrowsmith, represented at the Whitworth by a photo piece called *Gift of Tears*, is one such artist; she frequently uses her own body in her work in an effort to generate new meanings, meanings other than those traditionally imposed on the female nude by male artists. Knowledge of an artist's gender can affect not only the interpretation of a work, but also its critical appraisal. Some examples of this have become quite well known: Rozsika Parker and Griselda Pollock, in *Old Mistresses*, pointed to the irony of the fact that certain critics had claimed that the vigorous brushstrokes of painters such as Frans Hals were beyond the capacity of women artists, when in fact many paintings by Judith Leyster had for centuries been thought to be by Hals; indeed, Leyster's very existence was only rediscovered in the late nineteenth century when a painting attributed to Hals was found to carry Leyster's signature (Parker and Pollock 1986:8). Perhaps less well known is an example recorded in a letter written in 1921 to Vanessa Bell from Roger Fry, describing a lecture which Fry had just attended by the painter Henry Tonks (Fry 1972:507). The main burden of the lecture was Tonks' regret that women artists always imitated men, and to illustrate this point Tonks pointed, as an example of obviously superior work, to a painting which he thought was by Duncan Grant. However, as Fry gleefully reported, the painting was in fact by Vanessa Bell herself. Such examples as these have their funny side, so it is important to remember that expectations and beliefs about the type of work which women produce can lead to the undervaluing of an artist's entire output, as is undoubtedly the case with the pair of objects illustrated on page 17.

It is not only that, as these examples suggest, knowledge of an artist's gender can affect the evaluation of individual works; it can also play a crucial role in the establishment of the very criteria against which individual works are measured. Indeed, fundamental notions about the nature of art itself are affected by gender, especially in so far as the most widely accepted definition of art is that which is collected and displayed by art galleries. Art galleries in Britain have played a vital role not only in the processes by which categories such as art and craft have been defined, but also in the hierarchical positioning of these categories. These hierarchies continue to be reflected and

reaffirmed today by common gallery practices; it is, for example, deemed unacceptable for objects defined as art to be displayed in a crowded hang, whereas objects defined as craft, frequently the arena for women's work, are nearly always shown in this way. More fundamental, however, to the nature of art galleries is the way in which their basic function is seen as the preservation as well as the display of the works they collect. This has meant that galleries have always had a tendency to collect only those works which could be preserved, so that, as Germaine Greer has pointed out, the fact that women's creativity has overwhelmingly been expended in the production of things which have been eaten, used or worn till they rotted has meant that their work has largely been excluded from museum collections (Greer 1991). The ideology fundamental to the existence of art galleries which defines art as something which is both worth, and capable of, being preserved is one which sits uneasily with the ways in which women in different cultures and at different times have expressed their creativity.

The beginnings of the long process by which certain types of production were defined as art and given greater prominence and authority whilst others were categorised as a lesser mode described as craft, predate the formal institution of museums and galleries in this country. Galleries have nevertheless played an important part in confirming not only the lesser status of craft but also the association of women with craft. The Whitworth's collections provide a particularly good basis for examining changing attitudes towards the production of textiles in this country, from the Middle Ages, when they were accorded the highest status, equal to that of architecture and painting, through the gradual processes by which their production became associated with women rather than men and their status correspondingly declined.

Feminism, art history and art galleries

The format of the book also provides a way of introducing the two main areas in which the work of feminist art historians during the last twenty-five years or so has made us aware of how works of art are defined, categorised and studied: firstly, the fundamental task of gathering information about the work of women artists which has been lost, misattributed or simply unnoticed, and secondly, the study of the ways in which women, and other issues such as sexuality and childbirth, have been represented in works of art. As we have seen, it is important that these issues are considered in the context in which most of us come into contact with works of art: the art gallery. This book is, however, not only about galleries but also about their visitors, and their role in the complex processes through which meaning or significance is produced in an object. In this respect the book focuses attention on a further, and more recent, contribution which feminist art historians have made to the ways in which we study and think about works of art: the reintroduction of the role played by both the individual producer and the consumer of an object into the analysis of the effects of shared ideologies, and issues of class, race and national identity. The brief analyses accompanying the pairs in this book emphasise that the issue of gender can never be satisfactorily dealt with in isolation, but always involves the consideration of a range of other issues connected with the distribution of power, such as class and race. But art historians in general, and feminist art historians in particular, have come to realise over the past few years that over-concentration on these large issues can still leave a number of important questions unanswered.

The first concerns the issue of 'the death of the author', a concept which obtained wide currency in academic art history through the influence of essays by Roland Barthes (Barthes 1977) and Michel Foucault (Foucault 1986). By making clear the processes by which an author is 'constructed' through a number of different discourses, these essays provided, during the 1980s, a vital corrective to many decades of art historical study which had over-emphasised the biographical history of the producer of a work of art as the sole guardian of the meaning and significance of that work, to the

exclusion of any other possible historical and cultural contexts. Like many necessary correctives, however, the pendulum began to swing too far towards a total denial of any consideration of the individuality of the producer. This denial caused particular problems for those art historians working in art galleries, since the questions which visitors most frequently ask about a work of art concern the life and character of the person who made it. Art historians who in the late 1970s and early 1980s embraced with enthusiasm the introduction of a theorised approach to their discipline have only belatedly begun to realise that the tenacity of this interest in notions of individual creativity, which for many people is the fundamental stimulus behind their visiting any art gallery, must also be taken into account, but in a way which avoids the pitfalls of the older approach which assumed that the biography of artists 'explained' their work in a simple and direct way.

This issue is of particular significance for museum curators because the traditional way of classifying works of art in Western museums and galleries has been by the identity of their creator. In many cases such classificatory systems structure not only the way such collections of works of art are indexed but also how they are stored, so that an essential prerequisite of locating a work of art in most European art galleries is to know the identity of its producer. Such practices both resulted from, and contributed to, the over-emphasis on the individual producer discussed above; it is important here, however, to note that the widespread introduction of computerised systems of cataloguing and indexing in museums is now beginning to make it possible *not* to prioritise the name of the artist in the recording of information about a work of art. Even the most basic computer systems make it possible for information about a collection to be sifted according to numerous other criteria such as date, subject matter, even size or medium. This does not mean that authorship should be discarded as an organising category; rather that it should simply take its place as one of many different ways of approaching, and asking questions about, works of art.

A second important question which the 'new art histories' problematised is the notion of quality. Some years ago Anita Brookner voiced what was then a quite widely held belief that 'new art history' (she saw it as a single new approach, rather than a number of different new approaches) was 'at its most exciting when dealing with second-, third-, or fourth-rate paintings' (quoted in Pointon 1990:2–3). The implication of this statement for the present project is that, whilst it may be interesting to use the collections of a provincial English art gallery in this way, it would not be an appropriate format in which to analyse the more important works in a national collection, such as the Tate or the National Gallery. It is certainly true that British national galleries have, for the most part, clung steadfastly to older methods of displaying and interpreting works of art, whilst many provincial museums and galleries, and some national museums, have continued to develop new ways of helping their visitors to engage with the works in their collections. The unspoken assumption behind the lack of change, indeed the positive rejection of display and interpretation techniques by British national galleries is that paintings of the highest quality do not need interpretation; their very quality is thought to ensure that they communicate to, and are appreciated by, large numbers of people regardless of their cultural background. It is, however, my belief that the only reason for not using works from the National Gallery in this book is the celebrity that they have acquired by being in a national collection, so that for many readers the whole point of the exercise would be thwarted by their knowing the answer to the question without having to give its implications the slightest thought. A further problem would be, of course, that the National Gallery still contains an even smaller percentage of works by women artists than many provincial galleries, so that it would have been difficult to find a sufficient number of works to include in the pairs.

Art galleries and their visitors

A further issue which the 'new art histories' were initially rather unwilling to deal with was the question of individual response to a work of art, and the issue of what Marcia Pointon has called 'intersubjectivity': 'What happens when an individual engages with and is moved by imagery produced by another individual?' (Pointon 1990:1). The format of this book encourages particularly close attention to be paid to the variety of individual responses to works of art. Reading or discussing the book with a companion will, as many visitors to the *Women and Men* exhibition discovered, force the repeated confrontation of questions such as 'What effect does my gender have on my responses to a work of art?' and 'Does my sexuality affect my interpretation of an image?'. These are questions which mirror and shadow the first question which readers are asked – 'Which is the woman's work?' – which focused on whether an artist's gender and/or sexuality affects the choices he or she makes in terms of media, subject matter and imagery as well as size, shape and colour.

The exercise of putting together works of art in pairs thus brings with it an emphasis not only on the individual producer but also the consumer, which provides a useful counter-balance to some earlier developments in academic art history. There is now a growing interest in studying the responses of visitors in art galleries, and in understanding the variety of ways in which visitors view and respond to works of art. Perhaps inspired by Pierre Bourdieu and Alain Darbel's *The Love of Art*, written in 1969 and translated into English in 1991 (Bourdieu and Darbel 1991), art historians and museum marketing departments alike have begun to investigate not only the social structure of art gallery audiences, but also the range of possible responses which visitors might have to the works on display, which can range from enjoyment of a narrative, a well-told story, to aesthetic contemplation which all but ignores narrative content in favour of a mood created by the perception of shapes and colours. These, then, are factors which must be considered in conjunction with the questions about the effects of gender and sexuality discussed above.

Feminist interventions in art galleries

Since the late 1970s art galleries in this country have witnessed, indeed hosted, a growing number of feminist interventions which have questioned many of the ways in which such institutions operate, not only in terms of the way their visitors interact with the works on display, but also in terms of their selection, display and interpretation of objects in their care. The issues discussed above, of authorship, quality, and visitor response, have been amongst the many questions which such work has raised, both for those working in galleries and for their visitors. As *Women and Men* was part of this wider movement, it might be useful here to consider briefly some of the many developments in museum practice which the exhibition both built on and contributed to. From the late 1970s onwards, one of the most urgent concerns for many feminists, artists, art historians and curators alike, was simply the tiny proportion of works by women that were owned and/or displayed by galleries in Britain. For some the answer was to begin to redress the balance by organising exhibitions consisting entirely of work by women artists; the work of contemporary women artists in particular was frequently exhibited in 'women only' shows, although with perhaps decreasing frequency in the face of growing fears that such an approach would merely lead to 'ghetto-isation': to the work of women being seen as separate from, and hence a dismissible alternative to, the most important developments in contemporary art which were still regarded as that being produced by men.

Such exhibitions perhaps inevitably led to proposals for creating a permanent collection of art by women, culminating in the foundation in 1987 of a National Museum for Women in the Arts in Washington (Higonnet 1994), followed by a campaign begun in 1994

for a similar institution to be founded in this country (Morrison 1994). The main arguments in favour of institutions such as these, collecting and displaying only art by women, have been that, since existing institutions are either unwilling, or unable to afford, to add to their collections examples of women's art in sufficiently large numbers to correct the current imbalance in favour of art by men, it is necessary to have institutions solely dedicated to this purpose. The strongest argument against such projects is that, like 'women only' exhibitions, they inevitably lead to a process of 'ghetto-isation', whereby women's art is viewed in isolation and thereby regarded merely as an addendum, an afterthought to the main story of art which continues to be seen as the story of art produced by men. Nevertheless, the surprising impact of the experience of visiting the National Museum for Women in the Arts, standing in a traditionally-hung room full of paintings of traditional subjects, such as still-lives, history paintings and female nudes, is sufficiently unusual to make us stop and think. The mere fact of knowing that each of these paintings was produced by a woman certainly made me consider the paintings differently: it became possible to consider that the female nudes were painted without the question of sexual desire coming to the fore, whilst a painting of a pubescent girl (*The Abandoned Doll*, by Suzanne Valadon, 1921) must have been produced from experience of the changes which the female body goes through, rather than observation. Thought-provoking though such experiences are, I remain convinced that it is better to consider such questions in the context of art produced by both women and men, and that it is, furthermore, vital that the existence of newer institutions dedicated to the preservation and display of art by women should not be allowed to absolve existing institutions from their duty to consider questions such as those raised by this book.

An important aspect of developments in the exhibiting of women's art were shows such as *Women's Images of Men* held at the Institute of Contemporary Art in London in 1980, which exhibited contemporary work by women on a particular theme, in this case views of male bodies. Many of those visitors able to get past the 'forest of penises' which so disturbed many reviewers, felt that this show demonstrated that there was not one, monolithic view held by all women of men, but instead a range of quite different and challenging voices and perspectives (Kent and Morreau 1990). Such developments in the exhibiting of contemporary art, and exchanges of views between feminist curators and their academic colleagues, encouraged similar developments within the collecting and display of historic art, with many galleries making genuine, if belated, efforts to ensure that their collecting policies encouraged the acquisition of both contemporary and historic work by women in sufficient numbers. This was complemented by more strenuous efforts to exhibit the work of women artists of the past, such as Gwen John (Langdale and Jenkins, 1985) or Angelica Kauffman (Wassyng Roworth 1992), which drew on, and presented to a wider public, the painstaking research which had gone into identifying and tracing often lost or misattributed work by women artists.

Hand in hand with these developments, however, were explorations of the ways in which women were represented in art, which eventually became seen as a sufficiently important issue for it to be explored by a national museum, in Gill Saunders' exhibition *The Nude: A New Perspective* (Saunders 1989). Other exhibitions combined both issues, as the title of one, *Painting Women*, implied; this show explored both the lives of Victorian women artists, and the images of women which they painted (Cherry 1987). The late 1980s and early 1990s saw a growing number of exhibitions exploring the treatment by women artists of subject matter which seemed of particular concern to women, such as *Mothers*, shown in Birmingham in 1990 (Kingston 1990), as well as considering art forms other than painting which have been particularly important in women's histories, such as embroidery, explored in two exhibitions shown in Manchester in 1988 (Harris and Barnett 1988).

13

Many of these developments, however, took place in galleries whose main function was to organise exhibitions, particularly of contemporary art. Most of these, such as the Ikon in Birmingham or the Cornerhouse in Manchester, did not have the responsibility for looking after and caring for permanent collections of works of art, such as those owned by the Whitworth and by publicly-owned galleries up and down the country. These latter institutions found it difficult to reconcile the existence of, and their responsibility for, collections built up using criteria which were now being fundamentally questioned and disrupted by such feminist interventions. Some, unwilling or unable to respond to this challenge by changing their whole approach to the display of their collections, instead invited feminist art historians to inspect and produce an 'alternative view' of their existing displays, as Griselda Pollock was invited to do at Manchester City Art Gallery (Pollock 1987), or, more recently, invited feminist artists and/or art historians to make and display their own selections from the gallery's permanent collections, such as Maud Sulter at the Tate Gallery in Liverpool (Sulter 1991). Such reassessments have included questioning the presentation of masculinity as well as femininity, such as the selection from the Tate Gallery's permanent collection made by Andrew Stephenson in 1993 (Stephenson 1993). Such projects have been important in revealing the assumptions upon which the collections of such major national institutions have been built, issues as basic as the fact that the absence of large numbers of works by women artists in our national collections has led to the belief that few women have produced art. Such assumptions had remained largely unspoken and unexamined in the past, so that it continued to be worthwhile pointing them out. Nevertheless, exhibitions such as *Visualising Masculinities* were still restricted in the issues that they could raise by the very character of these collections, including, in this instance, the very lack of paintings of men by women artists owned by the Tate Gallery. Given the necessarily slow rate at which works can be acquired by public galleries, the weight of the collections already built up in previous decades, in many cases over a century, of collecting, will necessarily appear to outweigh attempts to move in new directions for many decades to come.

However, it is in this respect that I hope this book, as well as introducing younger readers to issues in feminist art history and feminist interventions in art galleries, might also give heart to museum and gallery curators who at times feel overwhelmed by the difficulties they face in trying to reassess and represent the collections which remain their main responsibility. A notable tendency in museum and gallery practice during the 1980s, alongside those discussed above, was for curators to concentrate all their energies, and a large percentage of their museums' resources, financial and otherwise, on the production of large scale loan exhibitions, consisting almost exclusively of works borrowed from other collections in this country and abroad, thus enabling the organisers to make their own selections of exhibits, rather than be constrained by the collecting policies of their predecessors. Many were encouraged further along this path by the arguments of colleagues concerned with marketing, and by the evidence of visitor figures, which suggested that people would make the effort to come and see exhibitions which they knew were temporary, and included work that they might never again get the chance to see, but were likely endlessly to defer making visits to displays of works owned by their local gallery, in the belief either that they would always be there for future viewing, or that they had been seen before and were not worth viewing again. *Women and Men* was in part an attempt to counter this tendency, and to demonstrate a number of things to other disheartened gallery curators: firstly, that it was possible to produce interesting and challenging exhibitions selected entirely from the resources of a provincial gallery's permanent collection; secondly, that this need not involve huge expenditure (the budget for *Women and Men* was just over £300); and thirdly, that visitors *will* make the effort to view works owned by their local gallery if they are presented in sufficiently new and challenging ways –

indeed, the attendance figures for *Women and Men* exceeded those for many of the temporary loan exhibitions put on at the Whitworth. Such initiatives need not, of course, be wholly or even partly feminist in their intention, although it does seem to me that the rethinking of art histories which feminist work has encouraged is so fundamental as to make it difficult to imagine a rethinking of gallery display techniques which does not at least in part involve feminist perspectives. If this is the case, however, I might also hope that this book will be of some help towards the problems faced by curators, especially women curators, trying to introduce different ways of thinking into their galleries' exhibition programmes; women are more than likely to be working in subordinate positions, and to have to face the task of persuading male superiors of the validity of their work. In her review of *The Subversive Stitch* exhibitions, for example, Pennina Barnett noted that without exception all of the curators who booked the exhibition to tour to their galleries were women (Deepwell 1994:77). It is also true that this gender hierarchy, which still holds sway in many galleries in this country, in many cases underpins the hierarchy of media discussed above; for example, the Whitworth is now informally divided into a fine art department staffed entirely by men, and wallpapers and textiles departments (the term 'decorative arts' has been resisted) staffed entirely by women.

Using this book

A final word, then, about the structure and contents of this book. The interpretation presented in the commentaries on the pairs of objects owes an enormous debt to several decades of work by a whole range of feminist writers and thinkers. I have not attempted here to give an introduction to the development of feminist art history, since this has been so well done by Whitney Chadwick in her introduction to *Women, Art, and Society*; developments in feminist thinking which have taken place since the publication of that book in 1990 are discussed in the introductions to each of the chapters in this book, as well as being used in the texts accompanying the pairs. The aim of the present writer is not to introduce further advances in theory; rather it is to present new research about, and interpretations of, individual objects and their producers in a format which is approachable for the non-specialist reader. It has been my intention to produce a book which will be of use both in the living room and in the classroom. Teachers, I hope, will find it a useful format in which to challenge students, whilst non-specialist readers should find the format as stimulating and provocative as did many visitors to the exhibition. Fellow museum and art gallery curators, whilst possibly finding their specialist knowledge prevents them from participating fully in considering the question 'Which is the woman's work?', may nevertheless find the book suggests to them many other new ways of presenting their permanent collections to their visitors.

One important aspect of the exhibition which I've tried to maintain here is that visitors were not obliged to go around the display in any prescribed order, so that they could look at as large or as small a number of pairs as they pleased in any order in which their attention was attracted. The very nature of a book means that readers feel more obliged than visitors to an exhibition to start at the beginning and work through to the end, and for this reason it has been necessary to introduce chapter headings, or subsidiary themes, into the structure of the book. This does not mean, however, that readers should feel discouraged from dipping into the book and reading about individual pairs of works in any order they choose. Whilst the chapters are designed to give some coherence and context to the individual pairs, and to draw out and emphasise some of the larger themes involved, care has also been taken to make sure that each pair makes sense on its own. It is also true that some of the pairs could easily have been put under almost any of the chapter headings, since all of them necessarily bring out an interrelated network of issues confirming the impossibility of considering gender issues in isolation from other historical and cultural concerns. What is more, the pairs themselves are by no means

immovable. Readers are encouraged to make comparisons 'against the grain' of these pairs, by contrasting works considered here in different pairs or even different chapters; they might find, for example, that comparing works produced at the same time, such as the orientalist painting discussed on page 52 and the Victorian domestic genre scene on page 86, or works produced in similar styles, such as the Impressionist techniques used in the works on page 52 and page 110, might yield useful results; even two works by artists of the same gender, such as the self-portraits on pages 110 and 43 make interesting juxtapositions.

One final question should be answered here: do we need another book about feminism and art? Gender issues have now become an acknowledged aspect of many parts of the National Curriculum, so it would seem that in many ways the flood of new feminist writings is increasing in inverse proportion to the perceived need to convince large numbers of people of the importance of the issue. However, as Carol Duncan has recently pointed out, many of these publications focus on 'what today is termed "theory" – a discourse informed by mostly French-based post-structuralist linguistic and psychoanalytic thought' (Duncan 1995). The language in which such discussions are conducted inevitably leads to the majority of art gallery visitors, including large numbers of the very teachers charged with the task of leading their pupils through the National Curriculum, being unable to engage with the issues and arguments. If anyone is led to doubt for a moment the necessity of continuing to problematise the issue of gender, they need look no further than the latest issue of their daily paper; as I write, the front page of The *Guardian* and several of the tabloid newspapers features a row which has broken out between Labour and Tory party members of a local council which has produced a paper proposing to adopt a policy of introducing gender issues to children as young a three and four in nursery schools. The brief flurry of comment and criticism caused by this row has made dismally clear the extent to which many people in this country continue to cling to the idea that gender-differentiated behaviour, in children as well as adults, is 'natural', and that the education of children should not be allowed to interfere with this 'natural' development. During the same week a survey of the ways in which women's lives have changed over the last twenty years revealed that whilst more women are going out to work, they continue to be paid less than men whilst at the same time being burdened by a far greater proportion of household chores. All this suggests to me a great need not only for this book but for many more like it.

Illustrations

Please note that artists' signatures have been touched out or cropped off colour illustrations where the gender of the artists would have otherwise been revealed

The answer to the question 'Which work was produced by a woman?' is given on the page referred to after each question, where the work produced by the woman is shown ABOVE that of the man

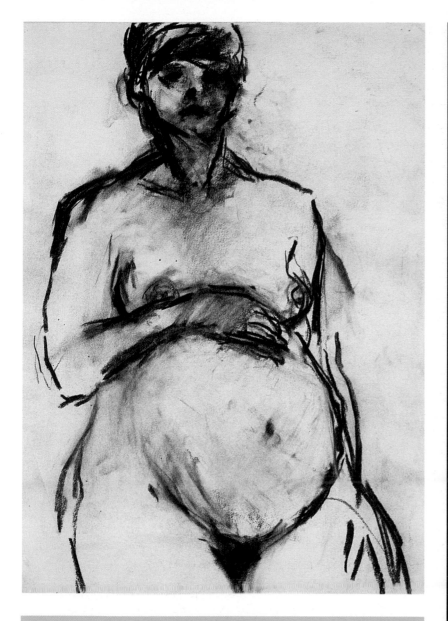

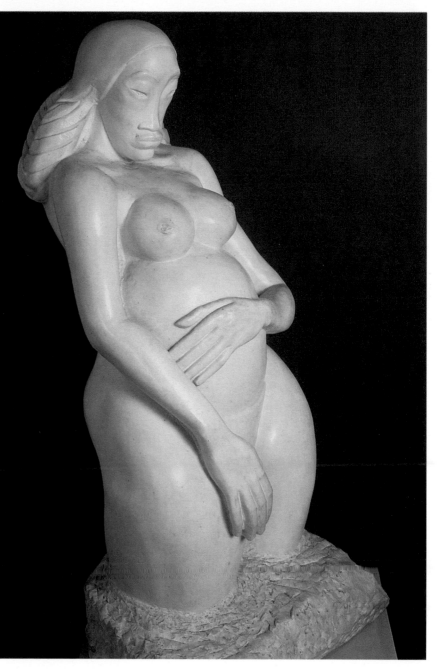

Both these works represent pregnant women.
Which was made by a woman? (See p.43)

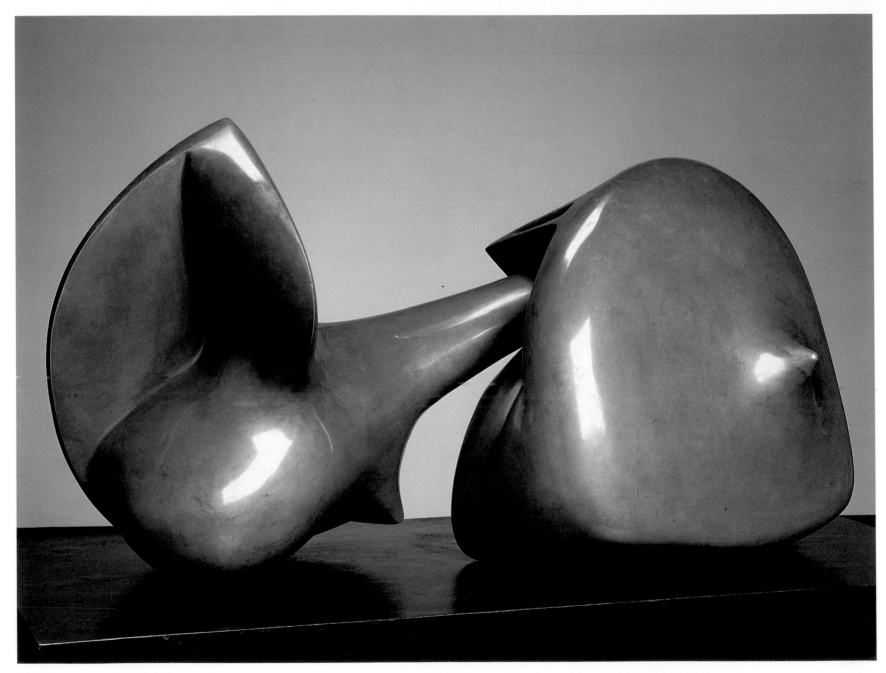

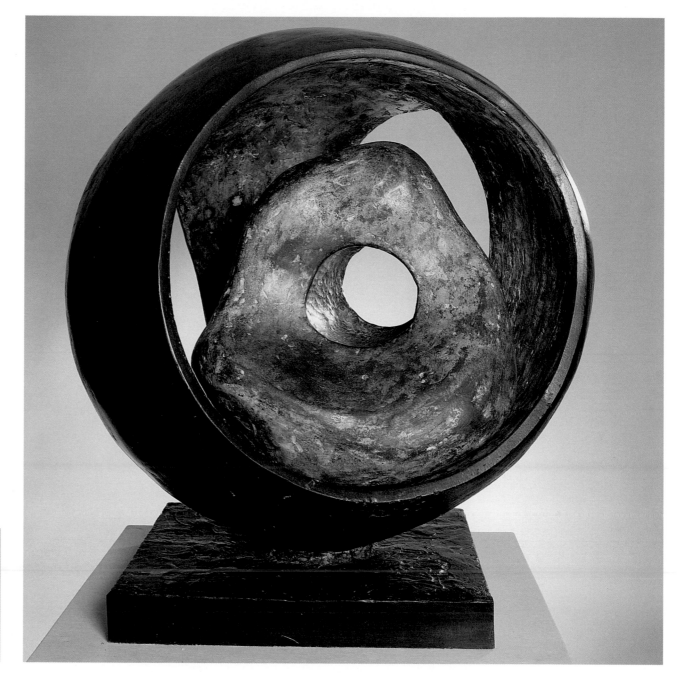

These bronze sculptures were both cast from artists' plaster models. Which model was made by a woman?
(See p. 46)

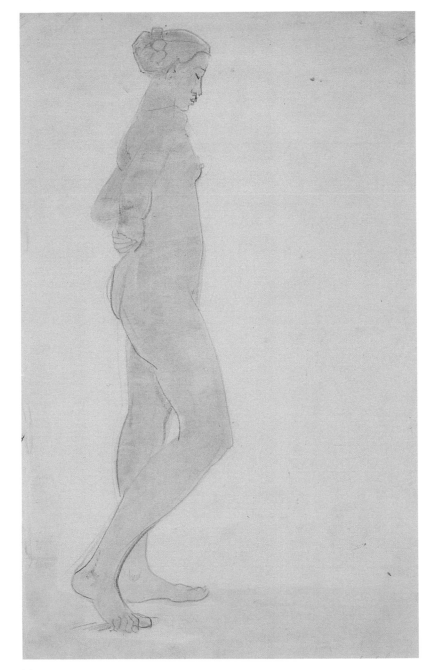

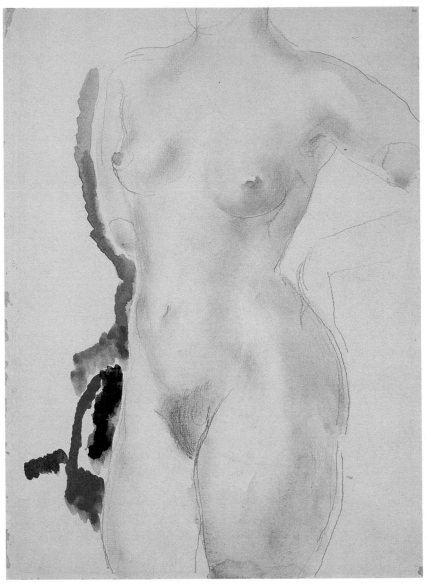

These two drawings are similar in size, medium and date. Which was produced by a woman? (See p. 49)

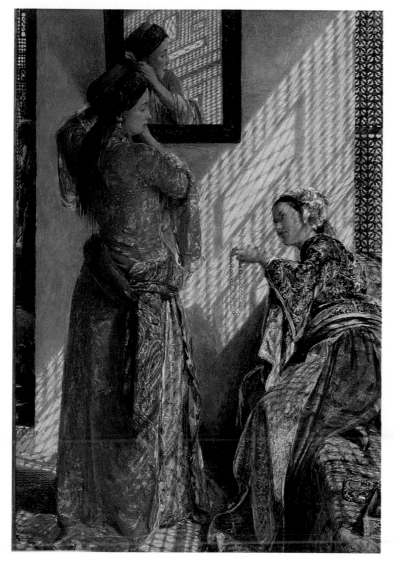

These images both show two women alone in an interior; the oil painting was produced almost forty years earlier than the watercolour. Which was painted by a woman? (See p. 52)

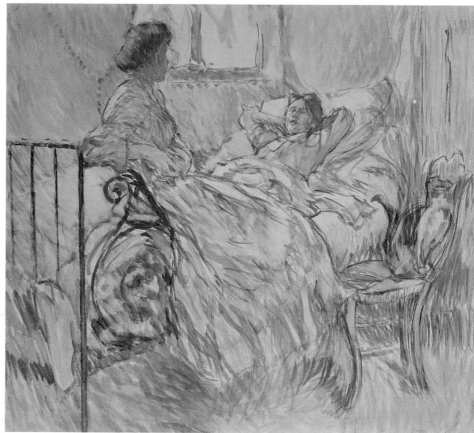

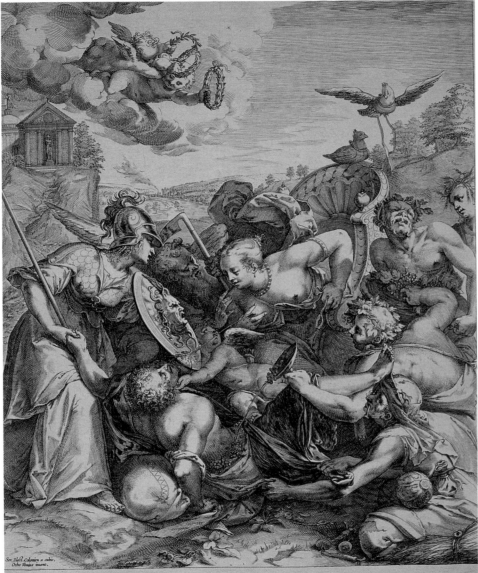

Ser. Høøk. Coloniæ a cubic.
Otho Venius invent.

Blanda Venus Iuuenem prædulci lacte iacentem
 Lactat, cum Bacchus irrigat usq; mero.
Immoderata Ceres comes est tantisper, Egestas
 Sordida dum miserum prendat humiq; premat
 Quo per iter durum ad Virtutis Honoris et Ædem
 Impiger is tendat serta vbi honora ferat.

Dimouet at Tempus Venerem: eius et assecla Pallas
 Obijcit huic remoras illici ubique Deæ;
Delitijs Iuuenem hæc stolidis ne fascinet ultra,
 Mox illum pigra tollit amanter humo,

These works both reproduce compositions originally designed by other people in another medium. Which is the work of a woman: the engraving (left) or the embroidered box (front panel below, lid on facing page)? (See p. 58)

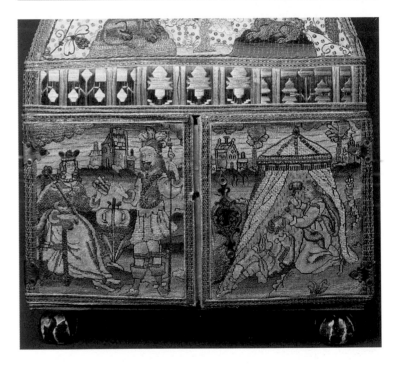

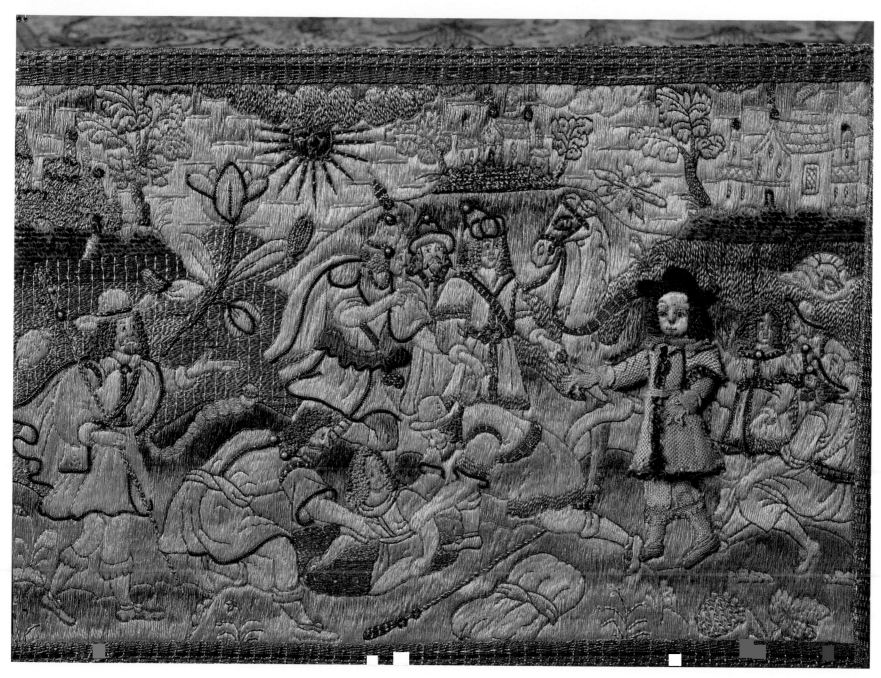

23

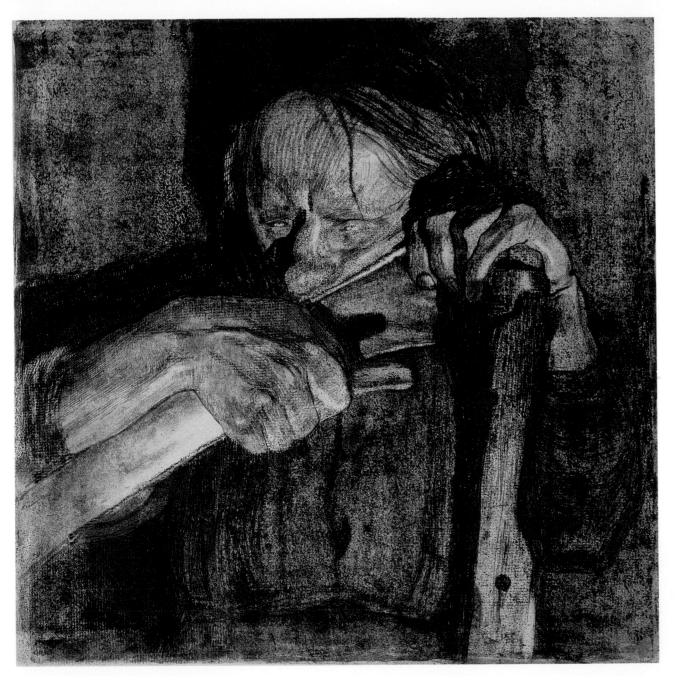

These prints were both made around the turn of the nineteenth century. Which print was made by a woman? (See p. 61)

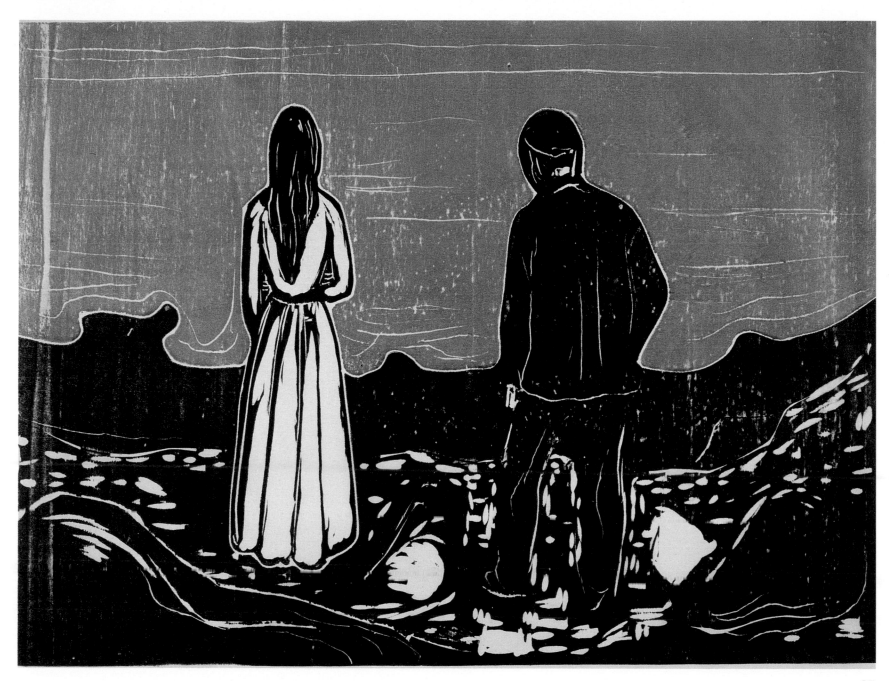

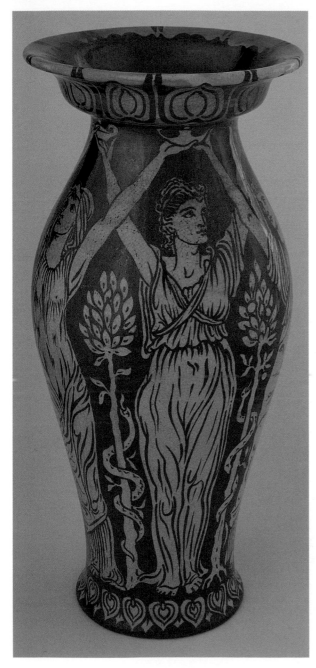

Each of these objects was made in Britain in the years around the turn of the nineteenth century; one was designed by a man, the other by a woman. Which was designed by a woman? (See p. 64)

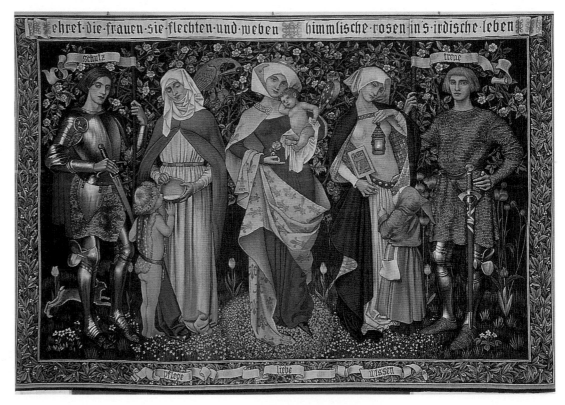

Both these works on paper relate to written texts, a song and a poem. Which was painted by a woman? (See p. 67)

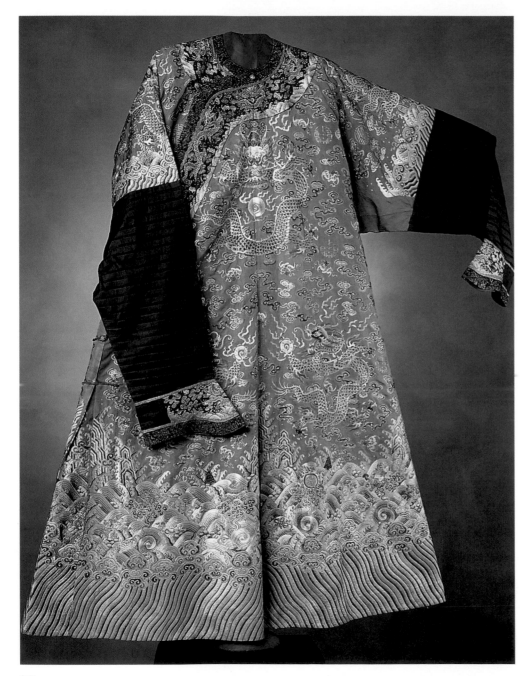

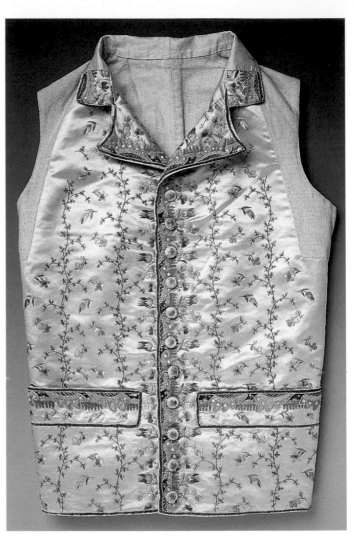

These two pieces of clothing both signified the high status of their male wearers in the cultures in which they were produced. On which piece was the embroidery done by a woman? (See p. 72)

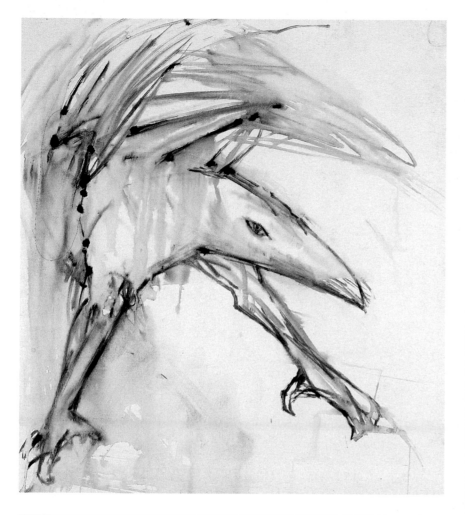

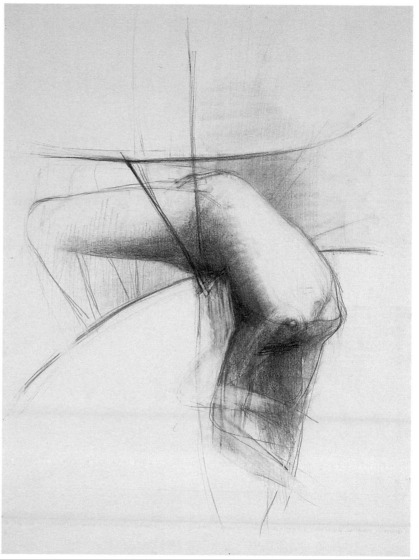

These two drawings were both executed in the same year. Which was drawn by a woman? (See p. 75)

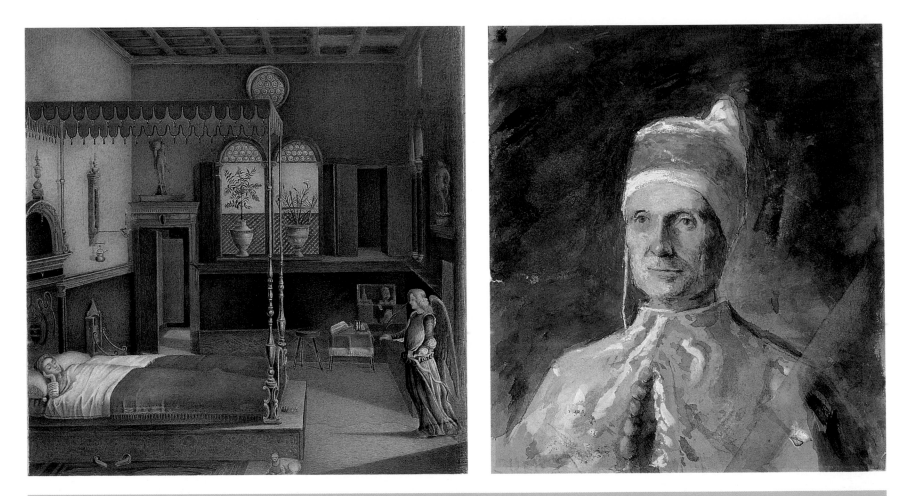

Both these Victorian watercolours are copies of Italian Renaissance paintings. Which is by a woman? (See p. 78)

These prints were both made during the 1980s by men and women working in collaboration. Which image was conceived (as opposed to printed) by a woman?
(See p.81)

These two works are both watercolours of similar size and date. Which is by the woman artist? (See p. 86)

These are fragments of two Victorian wallpapers. Which wallpaper incorporates images designed by a woman? (See p. 89)

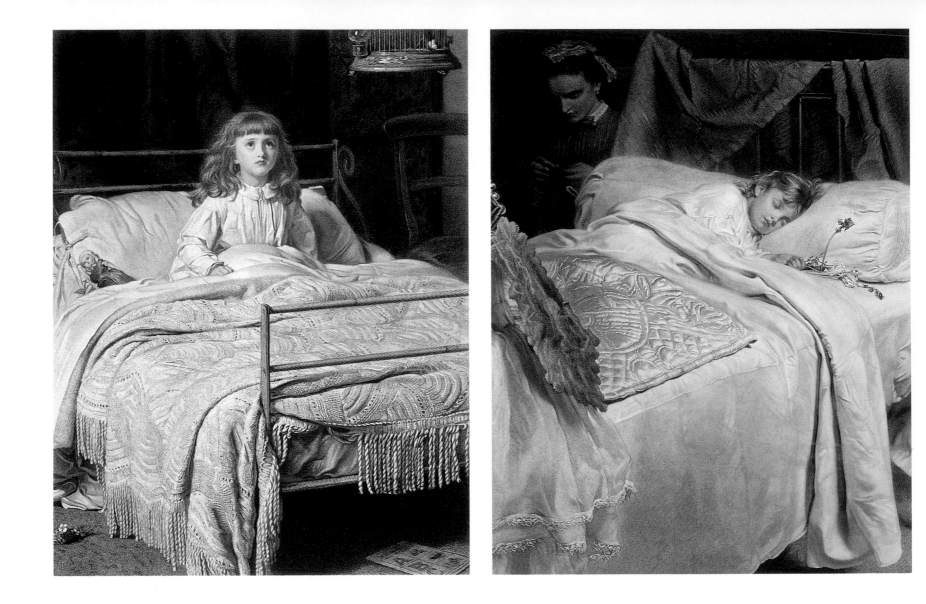

The picture on the right was embroidered in wool on canvas, those on the left were printed in ink from metal plates onto paper. Which work was executed by a woman? (See p. 92)

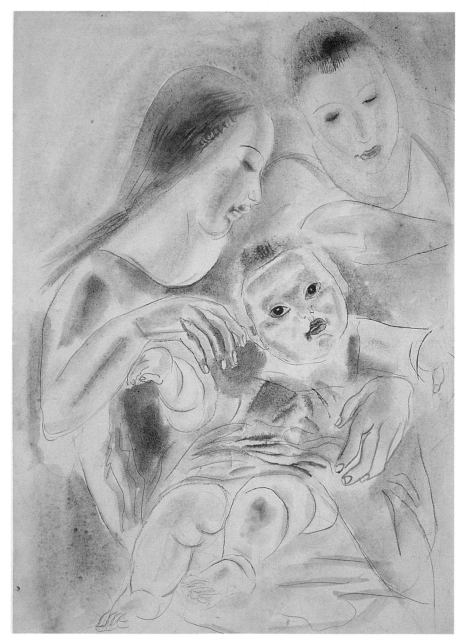

The work on the right was drawn thirty years after the work on the left. Which was drawn by a woman? (See p. 95)

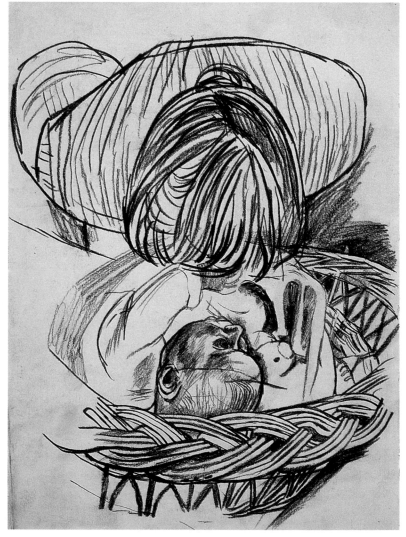

One of these textiles was designed by a man, the other by a woman. Which textile was designed by a woman? (See p. 101)

One of these objects was designed by a woman and made by men, the other was designed by a man and made by women. Which was designed by a woman? (See p. 104)

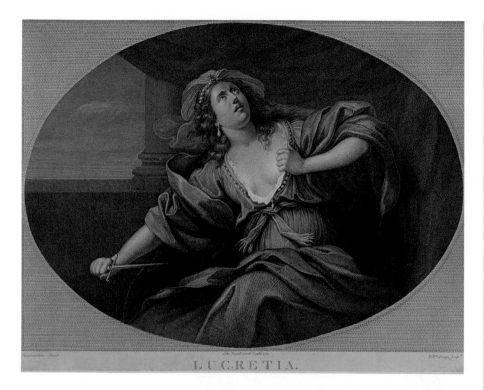

LUCRETIA.

These are both reproductive prints published in London in the 1780s. Which print reproduces the work of a woman? (See p. 107)

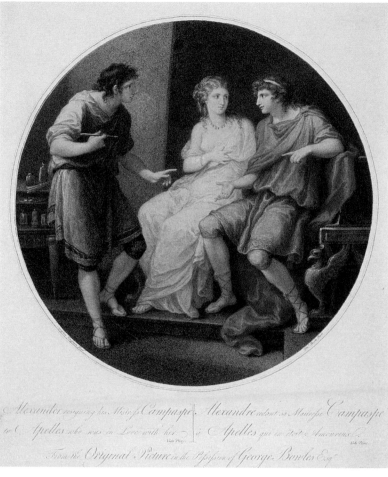

Alexander resigning his Mistress Campaspe to Apelles who was in Love with her.

Alexandre cedant sa Maitresse Campaspe à Apelles qui en étoit Amoureux.

From the Original Picture in the Possession of George Bowles Esqr.

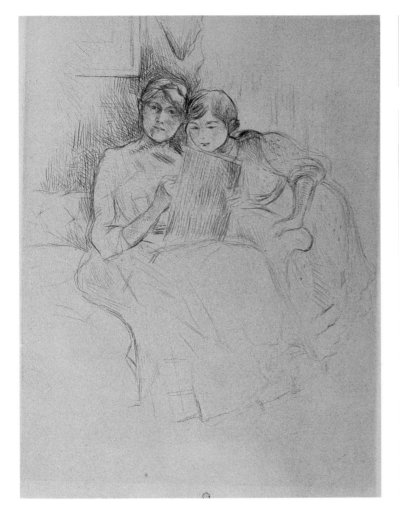

One of these works is a drawing of someone making a print, the other is a print showing someone drawing. Which was made by a woman? (See p.110)

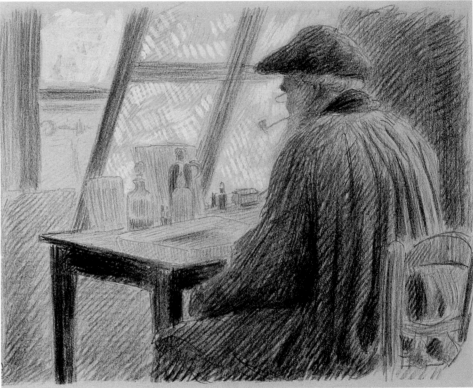

1 Art and the female body

More than any other subject, the female nude connotes 'Art'.

Lynda Nead (Nead 1992:1)

NAKED FEMALE bodies are a familiar sight in art galleries. Naked male bodies are rarer. The Whitworth, for example, owns over fifty times as many images of the female as of the male nude. One of the reasons for confining this chapter to images of the female body was the paucity of male nudes available in the Whitworth's collections; like many provincial galleries, the bulk of the Whitworth's collections comprise British art and design objects from the late eighteenth to twentieth centuries; the earlier period, when the male nude was more frequently an object of representation, is less well represented. Images of naked and semi-clothed female bodies which would evoke quite different responses if reproduced on page three of the *Sun* hardly raise an eyebrow when shown in an art gallery. One of the functions of an art gallery is to police the boundaries between art and pornography, presiding over an unspoken code which deems inappropriate certain types of response to naked figures shown in the context of 'art'. Inappropriate kinds of behaviour have, in the past, literally been ejected from the Whitworth: Anthony Burgess recalls being thrown out of the Gallery when, as a young boy, 'in the company of other kids I had sucked at the marble breast of a Greek goddess and been ejected by one of the curators' (Burgess 1988:91); such statues of female nudes were displayed by the Gallery as

examples of the very highest achievements in the history of art.

This chapter examines a group of nineteenth- and twentieth-century representations of female bodies from the Whitworth's 'fine art' collections in order to consider the power of images such as these, defined as being important by their very presence in galleries such as the Whitworth. It will be clear from examining the illustrations discussed in this chapter that images which are produced or displayed as works of fine art are caught in a complex web of ideas and feelings, not only about the ways in which female bodies can be shown and should be responded to, but about which aspects of the female body are suitable for such treatment. Pregnancy, for example, has been a subject rarely tackled by artists and even more rarely shown in art galleries; a sculpture of a pregnant woman, *Genesis* (p. 43), was a *cause célèbre* when it was first shown in Manchester in 1932, causing both outrage and ridicule. This huge marble statue now stands by an archway in full view of most visitors entering the Whitworth Art Gallery, but it no longer causes such extreme responses, although images of pregnant women in other contexts, such as the front cover of *Vanity Fair*, remain contentious (see p. 45).

Many visitors to the Whitworth clearly feel that some aspects of the female body remain inappropriate for treatment by artists or for display in art galleries. A print, *Ashes to Ashes*, by Paula Chambers, dealing, amongst other things, with the subject of menstruation, caused outrage when it was exhibited at the Whitworth in 1992. A flood of complaints, written and verbal, included such outbursts as 'most upsetting', ABSOLUTE INSULT', '*Ashes to Ashes* seemed to me to be obscene and could make the University liable to prosecution' and 'Disgusting ... this is unquestionable [*sic*] absolutely offensive ... if I had a brush with me I'd have swept it up. This certainly is not ART.' (*Visitors Comments Book*, 1992). The insult felt by some visitors was clearly heightened by the fact that the print was not safely behind glass on the wall, in the accepted manner for displaying high art, which entails a discrete distancing of the viewer from the subject of the work. Instead it was produced by applying sand through stencils on to the floor, so that some visitors clearly responded as though they were actually looking at menstrual blood on the floor of an art gallery; hence the comment, quoted above, that it should be swept up.

The extreme physical disgust evinced by responses to Chambers' work from both men and women points up the enormous strength of commonly shared but rarely articulated feelings about art and women's bodies. As Lynda Nead has argued, 'The representation of the female body within the forms and frames of high art is a metaphor for the value and significance of art generally. It symbolises the transformation of the base matter of nature into the elevated forms of culture and the spirit.' (Nead 1992:2). This, combined with the fact that, as Nead also argues, 'The obscene body is the body without borders or containment', helps us to understand more fully the feelings caused by Chambers' work. The artist's apparent refusal to transform the 'base matter of nature', and her insistence on representing traces of female bodies 'without borders or containment', for many viewers simultaneously devalued both art and the female body.

As readers examine the pairs of representations discussed in this chapter, they will confront not only some of the myriad of ways in which images of female bodies have been affected by ideological and other constraints both at the time of their production and later, but also their own responses to these images: feelings of pleasure, desire, discomfort or incomprehension. The process of looking at female nudes is, as Marcia Pointon has argued (Pointon 1990:10), unsettling to both male and female viewers, since it brings the question of the viewer's own sexuality to the fore. The subjectivity of the viewer will produce a range of different responses, some of which will depend upon the assumptions that are made about the gender of the artist. Discussion of the results with friends or in a classroom context will soon make apparent the complexities of the issues here.

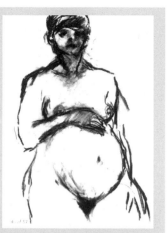

GHISLAINE HOWARD b.1953
Pregnant Self-Portrait 1987

Charcoal on paper
75.8 x 55.9 cm (D.1989.7)

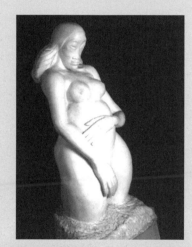

JACOB EPSTEIN 1880–1959
Genesis c.1930

Marble 162.5 x 83.8 x 78.7 cm (L.1989.3)
On loan from Granada Television Group

THE MAIN reason for comparing these two works is to ask readers firstly, before looking at the answer, to consider whether they expect to see a difference in the way this subject is treated by a man and a woman, and secondly, once they know the answer, to see if they can detect any difference between the treatment of pregnancy by a man, who cannot have had any personal experience of the subject, and by a woman artist who was in fact studying her own pregnant body.

There are several important differences between these two representations. The first is that, uniquely within this book, one was produced over fifty years earlier than the other. Ghislaine Howard's drawing is in a style which could have been produced at almost any time this century, so that anyone who had not seen it before would probably find it very difficult to date. Nevertheless, the fact that it was produced recently is crucial to the comparison between the two works, since it is only in the last twenty years or so that significant numbers of women artists have begun to explore pregnancy, childbirth and child-rearing in their art, and such subject matter has gradually become acceptable to many art gallery visitors. Part of this development was the exhibition *A Shared Experience* held at Manchester City Art Gallery in 1993, which drew on work produced by Ghislaine Howard when working as an artist in residence in the maternity unit of Saint Mary's Hospital in Manchester. Nevertheless, Howard has said that one of the greatest challenges she encountered was the fact that she felt she had no artistic tradition to draw on. She was familiar with centuries of representations of mothers and children in the 'Madonna and Child' form, and yet had never seen a Western painting of the most important subject that she was confronted with at the hospital: a woman giving birth.

Further major differences between the two works can be found in their physical nature – their size and medium – and the purposes for which they were produced. Howard's drawing is under half the size of Epstein's work, and her chosen medium – charcoal – is, unless sprayed with fixative, impermanent, and has connotations of informality and privacy. The drawing, although standing as a work in its own right, was in fact part of an extensive series which led to a group of oil paintings charting the physical and psychological changes which Howard experienced during pregnancy. Epstein's work, however, was produced on a large scale in the formal and public medium of marble. These basic differences go some way towards explaining the vastly different receptions accorded to the two works when they were first produced. Howard's work caused hardly a murmur when it was purchased for the Whitworth in 1989, and likewise Epstein's work now provokes few comments from visitors to the Whitworth.

When it was first displayed in 1931 at the Leicester Galleries in London, however, *Genesis* provoked howls of protest and abuse. The extent of the response prompted Alfred Bossom to purchase the work in order to tour it around Britain, thus raising a substantial amount of money for charity by charging a small fee to the crowds of people who flocked to see it. Subsequently the sculpture was shown alongside other works by Epstein to similarly large crowds at Louis Tussaud's Waxworks on the Golden Mile at Blackpool beach.

Epstein's initial reaction, on hearing his work was to be shown at Tussaud's, was outrage; however, he later declared himself in favour of the work being seen by as many people as possible. In making this claim, however, the artist showed himself widely out of step with much contemporary thinking about art. Reaction to an earlier work by Epstein – five figures for the façade of a new building for the British Medical Association on the Strand – had shown that most contemporary critics felt that certain types of art , and in particular nude figures, should only be seen in carefully controlled circumstances by carefully selected people. The *Evening Standard* declared that 'figures in an art gallery are seen, for the most part, by those who know how to appreciate the art they represent' (Epstein 1963:23), whereas to show naked figures, as Epstein proposed, on the façade of a building in the Strand, 'To have

art of the kind indicated laid bare to the gaze of all classes, young and old, in perhaps the busiest thoroughfare of the Metropolis ... is another matter'. It was the duty of adult males to control and censor the kind of art to which the working classes and women were allowed access, and Epstein's nudes were 'a form of statuary which no careful father would wish his daughter, or no discriminating young man, his fiancée, to see' (Epstein 1963:23).

The context in which a work of art is interpreted is, however, created not only by its physical and cultural surroundings but also by the title appended by the artist or a curator. Ghislaine Howard did not give a title to her work; the title *Pregnant Self-Portrait* , was given by a curator when it entered the Whitworth Art Gallery, and presents it as simply an artist's study of her own pregnancy. The title *Genesis*, however, suggests that Epstein's work is not about a particular pregnancy, or even about the subject of maternity in general, but is instead dealing with a much larger topic: the 'genesis' of the human race, a universal beginning.

It was this larger aim which brought Epstein into conflict with so many people amongst *Genesis'* original audience. In order to express his idea of the primitive beginnings of mankind, Epstein turned for inspiration to art from Africa and the Pacific islands, of which he was a great admirer and collector. However,

whereas for Epstein the work of African sculptors could suggest something fundamental, 'primitive' in the sense of marking the earliest beginnings, for contemporary reviewers the word 'primitive' meant backward, underdeveloped. This in turn constrained the way in which the expression on the face of Epstein's pregnant woman was interpreted. Whereas Epstein wanted to suggest 'calm, mindless wonder', uneducated in the sense of still being instinctual, not overlaid with the unnecessary trappings of civilisation, the racism inherent in so much of British society in the years leading up to the Second World War meant that most responses to this sculpture were conditioned by a tendency to see certain facial features – thick lips, for example – as indicative of a lack of intelligence. The *Daily Express* headline of 7 February 1931 ran: 'EPSTEIN'S BAD JOKE IN STONE. MONGOLIAN MORON THAT IS OBSCENE.' (Epstein 1963:274). The choice of the word 'Mongol' here was dependent not on the actual features of *Genesis* herself, since Epstein based this on studies of African masks, rather than the features of the East Asian peoples of Mongolia. Instead the reference is again to the insistent link between non-Western racial types and an assumed lack of intelligence underpinning the labelling of people born with Downes Syndrome as 'Mongols' which has only recently been eradicated from common English usage. However, in the context of the subject matter

of *Genesis* this is especially important in that non-European racial types are also presented as having not only lesser intelligence but also greater moral and sexual licence. The idea that black men are both more sexually potent and less restrained that European men can be traced back to the eighteenth century and beyond. In this context *Genesis* caused particular outrage in that a subject matter which Epstein's critics insisted should be treated with delicacy was mixed with associations of those qualities of 'primitive' societies which most Westerners liked to congratulate themselves on having overcome.

The final insult was not only that this woman appeared to be non-European and unintelligent; she was also not beautiful, and this was if anything the most problematic issue. Epstein was violating two fundamental assumptions: that art, and women, should be beautiful. When told by a friend that most people could not understand why he had made *Genesis* so ugly, Epstein, with deliberately assumed incomprehension, replied that he thought she *was* beautiful. But in another context he made it clear that he was trying to create an image of femininity that deliberately eschewed contemporary notions of delicacy and beauty.

I felt the necessity for giving expression to the profoundly elemental in motherhood, the deep down instinctive female, without the trappings and charm of what is known as feminine ... How a figure like this contrasts with our coquetries and fanciful erotic nudes of modern sculpture. (Epstein 1963:139–40)

Here it may be useful to draw a comparison between the response to Epstein's work and that provoked by a modern image of pregnancy. In August 1991 the front cover of *Vanity Fair* magazine featured a photograph by Annie Leibovitz of the naked, pregnant actress Demi Moore. It aroused a storm of protest which has been compared to that caused by the first exhibition of *Genesis*, but which in fact contains significant differences. Amongst the vociferous minority defending the publication of the photo were a number who thought it demonstrated that pregnant women could still be beautiful and sexy: 'what a pretty sight it is!', 'Who says women can't ... retain their sexuality during pregnancy?' (*Vanity Fair*, October 1991:18–20). The problem here is that pregnancy entails a number of changes to a woman's body – swollen abdomen, enlarged breasts – which conflict fundamentally with the current ideal of slimness as feminine beauty, propagated by magazines such as *Vanity Fair*. Responses to the photo of Demi Moore demonstrated that attractiveness to men is still seen as the most important function of both art and a woman's body, in the latter case overriding any other function, such as that of producing and nurturing a child. If any art form presents a pregnant woman as unattractive, for example with what the *Daily Telegraph* described in 1931 as *Genesis*' 'face like an ape's ... breasts like pumpkins ... hands twice as large and gross as those of a navvy [and] hair like a ship's hawser' (Epstein 1963:276) she represents a challenge and a threat.

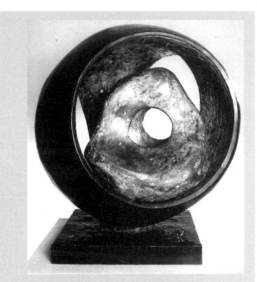

BARBARA HEPWORTH 1903–75
Sphere with Inner Form 1963
Bronze; from an edition of seven
101.5 x 93 x 89 cm (S.1968.3)

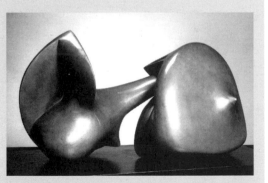

HENRY MOORE 1898–1986
Two Piece Sculpture No.7: Pipe 1966
Bronze, from an edition of nine
43.3 x 82.2 x 34.5 cm (S.1966.1)

THESE TWO pieces of sculpture appear at first glance to be so similar that readers might be forgiven for thinking they were made by the same artist. Both were produced in the same medium (bronze), at about the same time (within three years of each other), and both consist of two pieces. Furthermore, both use a similar abstract language or imagery which has been interpreted as containing references to the human body: Barbara Hepworth's piece has been seen as an image of a child within the womb, whilst Moore's imagery has been described as phallic and sexual, the 'pipe' or penis-shaped piece thrusting into the other form, and the projecting circular shape on the right suggesting a breast and nipple.

The use of an abstract vocabulary was, early on in the careers of both artists, widely regarded with suspicion. In spite of the fact that, by the mid-1960s, when these two works were produced, abstraction had been largely accepted by the art world, it remains, even in the mid-1990s, a problem for many art gallery visitors who do not feel part of the world of artists and critics, curators, dealers and art historians. Discussion of these two works with visitors to the Whitworth Art Gallery prior to staging the *Women and Men* exhibition quickly made clear that many visitors did not relate the abstract imagery to any natural form, human or otherwise. Indeed, most of those who attempted to describe their

responses focused on the medium rather than the subject matter of both works. The hard, coldness of the metal made many visitors think of machinery, or shipping parts like propellers, rather than the human body; indeed, male attendants at the Whitworth have nicknamed Henry Moore's piece 'the cement mixer', again suggesting that they see it as something hard and mechanical, rather than conveying ideas of life, flesh and growth.

It is clear, however, that neither artist intended these pieces to be interpreted narrowly as referring only to the human body. The way in which Hepworth wanted sculpture such as *Sphere with Inner Form* to be approached is suggested by this passage from her autobiography:

There is an inside and an outside to every form. When they are in special accord, as for instance a nut in its shell or a child in the womb, ... or when one senses the architecture of bones in the human figure, then I am most drawn to the effect of light. Every shadow cast by the sun from an ever-varying angle reveals the harmony of the inside and the outside. (Hepworth 1977:27)

Nevertheless the gulf between the ways in which many viewers interpret abstract works of art, and the 'correct' interpretation given by the artist or a curator, is an important issue. In the case of this pair, the answer to the question 'Which is a woman's work?' will depend firstly on whether or not the viewer sees the works as containing references to the

human body, and secondly on whether it is assumed that women are more likely, or more able, than men to investigate the condition of the child in the womb through their art.

Related to the question of whether women are more likely or able than men to investigate themes of fertility and childbirth through their art, is the fact that the image of human procreation has repeatedly been used by male artists and critics as a metaphor for artistic creation, and in particular for the production of sculpture. *Sphere with Inner Form* has itself been seen as a metaphor for the process of creating sculpture, although the imagery of procreation is more frequently encountered in the discussion of carved pieces rather than modelled work such as this. This language was particularly influential during the 1930s; the block being carved was repeatedly seen as female, and the carving produced as the child of the sculptor. The artist's role in its production was therefore described in sexual terms. Adrian Stokes wrote in 1933: 'The true carver attacks his material so that it may bear a vivifying or plastic fruit. He woos the block.' (Stokes 1933). Paul Nash, however, reviewing an exhibition of Hepworth's carvings, wrote: 'These works … suggest, as few are able to do, a process of exteriorisation. The sculptor has not imposed, but has inhabited the stone and grown within, outwards, as a child grows within the womb.' (Nash 1932). Hepworth, as a woman, was seen to produce a piece of

carved sculpture by identifying herself with the block, 'inhabiting the stone', and growing the work inside the stone as she would grow a child within her womb. By contrast, a male artist would make love to a block of stone, seen as separate from himself and female. The sculpture was the child to which the block 'gave birth' as a result of the artist's 'wooing'.

Such attitudes may have been expressed less explicitly in the decades following the 1930s, but there is no doubt that the lingering influence of this ideology continued to affect the critical appraisal of the two artists' work throughout their careers. These two pieces provide a striking example of the way in which artists' reputations can be affected by their gender. Hepworth and Moore were contemporaries, exhibiting together and often working in the same media. However, from early on in their careers, Hepworth was seen as a pupil or follower of Moore, despite the fact that, if anything, they influenced each other mutually. The way in which both artists' sculpture was exhibited had a marked effect on how their work was judged; Hepworth's work in particular was presented by many selection and hanging committees in ways which seemed to them appropriate to her nature as a *woman*, first and foremost. Hepworth herself complained bitterly about, but was powerless to alter, the way in which the selection committee for the British Pavilion at the 1952 Venice Biennale turned the 'fire and

imaginative juxtapositions' of her work into something 'discreet and ladylike' (Curtis and Wilkinson 1994:133).

Hepworth was also aware that her work was being judged against Moore's and found wanting. The problem here was that the very criteria which were used to distinguish 'successful' pieces of sculpture were ones with which Hepworth had little sympathy. There was, in Britain during the 1950s and early 1960s, great critical interest in the use of metal, especially bronze, for the production of sculpture. Moore clearly felt much more at home with this medium than Hepworth. The greatest critical prestige during these post-war decades was accorded to sculpture produced on a very large scale for public display in the open-air, for which bronze was seen as the most suitable medium. All this combined to produce a vogue for sculpture full of 'masculine' associations: big, public, hard. Hepworth felt, and was, disadvantaged in these circumstances, and it has been suggested that, instead of producing work more congenial to her, on a small scale in media such as wood or stone, she began to use bronze mainly in order to compete with Moore on equal terms. Hepworth was acutely aware that her sculptures were not going to be taken seriously unless they were big; she wrote: 'I just cannot afford to be represented by works ten inches high at International Shows.' (Curtis and Wilkinson 1994:143).

Hepworth was also aware of other factors which adversely affected her reputation. One of the main reasons for producing her *Pictorial Autobiography* was to try and correct the tendency to present her as Moore's follower; she wanted to 'put beyond dispute certain dates. My dates have been much altered by writers on Henry Moore.' (Curtis and Wilkinson 1994:146). In fact both artists actively tried to influence the critical reception of their work by publishing autobiographical writings, but the style of Hepworth's autobiography may have done her a disservice in that she is presented against a background of family and friends, the book is illustrated with pictures of her children and home life, whereas Moore's book (Moore and Hedgecoe 1986) only contains photographs of his work by a prestigious art photographer, bringing high art and aesthetics, rather than domesticity, to the fore. Indeed, Moore's work has continually been presented as the complete antithesis of domesticity: Richard Cork maintained that 'It is impossible to imagine a sculptor of Henry Moore's robust and expansive inclinations remaining content with work fit for drawing rooms.' (Cork 1988:14).

Since their deaths, however, the reputations of both artists have declined. Moore's has probably taken the biggest dip; his work remains highly regarded, but it is now clear that his earlier reputation was inflated by the urgent, nationalistic need to find a great *British* modernist who could represent this country on an international stage. Hepworth's reputation has probably declined to a lesser extent, and although, as the director of the Tate Gallery, Nicholas Serota, has remarked, 'It is not unusual for artists' stars to wane after their death', in Hepworth's case the situation is 'the more surprising given the growth of critical awareness of the contribution of women artists' (Curtis and Wilkinson 1994:3). However, in spite of Serota's hopes that 'a new generation of art historians' is now 'poised to make good that neglect', it is not possible to alter the fact that Hepworth's awareness of the ways in which her gender affected her critical reputation had a profound effect on the type of work which she produced; this cannot simply be 'corrected' by later reassessment.

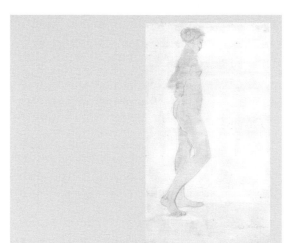

ETHEL WALKER 1861–1951
Standing Female Nude c.1927
Pencil and watercolour
39 x 21.3 cm (D.1938.5)

FRANK DOBSON 1886–1963
Study of a Nude Female Torso 1927
Pencil and watercolour
35.4 x 25.3 cm (D.1931.25)

WHEN SELECTING these drawings to be shown in the *Women and Men* exhibition I was convinced that most female visitors to the Whitworth would instinctively know which of the two had been produced by a man. To me there seemed an enormous difference between the self-contained pose of the figure in Walker's drawing, her eyes downcast, her body turned slightly away from the viewer with some suggestion of modesty, and the provocative pose of Dobson's nude, her breasts thrust forward, her nipples heightened in pink watercolour, and her identity removed by the omission of her head in order to focus on the erotically charged areas of her breasts and pubic hair. I felt sure that most women would recognise this latter image of a female body as having been produced by a man.

I was wrong on two counts. To begin with, everyone in the first group of women I showed this pair to thought that Dobson's nude had been painted by a woman. They explained that this was because they felt drawn by the luscious softness of the translucent colours, and that, being feminists, they confidently expected to be drawn to the work of women artists. Secondly, the initial stages of research quickly suggested that I might have been wrong about the apparent absence of erotic charge in Ethel Walker's drawing. As was the case with many of the pairs of works illustrated in this book, whereas

the Whitworth's research file on Dobson's drawing contained a wealth of material about the artist and related works, the file on Walker's drawing contained only a minimum of information. This is not entirely the fault of gallery curators; it is part of a larger neglect which means that more information is readily available about male than female artists. Walker's drawing appeared never to have been exhibited before, but had remained in a solander box in the Print Room since it arrived at the Gallery in 1928. It was only on beginning some basic research that it became clear that it had recently been suggested that Ethel Walker was one of the earliest lesbian artists to explore her sexuality through her art (Cooper 1986); assumptions that the erotic charge apparently suggested by Frank Dobson's drawing would be absent from Walker's therefore also had to be reconsidered.

Art historical accounts of the female nude in art have for decades been shaped and overshadowed by Kenneth Clark's celebrated *The Nude: A Study of Ideal Art*, first published in 1956. Amongst the three hundred illustrations in this book there is not a single work by a female artist, so that, although Clark discusses both male and female nudes, they are only investigated in terms of their representation by male artists. Clark also frequently, without specifying, assumes that the image discussed represents a female whilst the viewer is male. As Lynda Nead (Nead

1992) has pointed out, throughout the text Clark struggles to maintain a balance between the 'pure' aesthetic pleasures which can be afforded by the contemplation of a nude, and the competing concerns of sexual desire.

The desire to grasp and be united with another body is so fundamental a part of our nature, that our judgment of what is known as 'pure form' is inevitably influenced by it; and one of the difficulties of the nude as a subject for art is that these instincts cannot lie hidden ... but are dragged into the foreground, where they risk upsetting the unity of responses from which a work of art derives its independent life. (Clark 1956)

He admits that sexual feeling can never be entirely excluded from a viewer's responses to a work of art representing a nude figure; however, for him the success of such a work lies partly in its ability to enable its viewers, if not to dispense with it altogether, then at least to control these sexually charged responses so that they do not upset the aesthetic experience.

These issues are especially relevant to Frank Dobson's drawing in that its most obvious feature – the fact that the figure has no head – seems to have stemmed from the artist's desire to remove from the woman all indications of individuality and historical specificity. Her head would inevitably have indicated not only her individual identity but would also, through her hairstyle and absence or presence of make-up, have located her historically and culturally. Without the head

we have the illusion of a representation which belongs to no particular time or place. Dobson was primarily a sculptor, and he is known to have used drawings such as the Whitworth's as part of the process of creating a sculptural figure. He would first make a small model, or maquette, in clay, of the piece he had in mind. He would then decide on the scale of the finished work and order a block in which to carve the piece; next he would make numerous drawings from a life model posed in the attitude of the maquette, before finally starting work on the carving of the block. Whilst doing this he would, however, continually refer back to the drawings – sometimes numbering up to a hundred – which he had made from the life model. In all this, however, the identity of the female model was irrelevant. In the case of the Whitworth's drawing, the model is thought to have been Dobson's wife, so it was perhaps even more important to remove her head – to announce that it was not her individual identity, and certainly not her role as the artist's wife, which was important here. As Dobson wrote, 'The primary appeal of sculpture is to the emotion which results from contemplating the peculiar and apparently static evolutions which take place when a number of forms are superbly assembled.' (Casson 1933:47); this drawing partakes of essentially the same concerns.

The convention of studying parts of the body

in isolation is so well established that many visitors to the *Women and Men* exhibition accepted without question the fact that Dobson's figure was headless; indeed, some women said they had not even noticed the fact. Kenneth Clark explained the popularity of the fragment by saying that 'We have come to think of [it] as more vivid, more concentrated and more authentic.' (Clark 1956:219). One reason for this may have been that the fraudulent completion of excavated pieces of classical sculpture – the addition of unrelated arms, legs and hands to bodies originally found with some or all limbs missing – engendered in collectors and connoisseurs such widespread suspicion that they came to look on fragments as being more authentic, and thus more satisfying; the *Venus de Milo* has become an icon of feminine beauty yet she would now be unthinkable with arms. Feminist readings have, however, also explored the very disturbing aspects of life studies which exclude a woman's head, arms, legs, hands and feet, rendering her immobile and which, by focusing on breasts and genitalia, present the body solely as an arena for sexual gratification. The charge that images like Dobson's represent a male fantasy of female sexuality – passive, available and anonymous – is hard to deny; the point is underlined when we consider representations of male bodies fragmented in this way. Such images are less frequently encountered than their female counterparts, and where they do

occur they have tended to show a heroic figure struggling against his fate, stressing, through pathos and suffering, that the man is worthy of the sympathy of the viewer. During the 1970s a number of women artists explored the possibility of showing passive, sexually available men, but when their work was exhibited at the Institute of Contemporary Art in London in 1980, in an exhibition called *Women's Images of Men*, it drew howls of protest from male critics who denounced what they saw as violent castration by female viragos (Kent and Morreau 1990).

The function of Ethel Walker's drawing is less easy to determine than Dobson's. The outline of the figure has been traced through onto the back of the sheet of paper in a way that suggests that the image may have been transferred to another sheet, or possibly onto a printing plate, although no related print has yet been traced. There is no record of the artist having given a title to the work; the title by which it is now known, *Standing Female Nude*, is simply a descriptive one given, presumably, by a curator cataloguing the work after it had entered the Whitworth. However, Walker quite frequently gave titles of her own to such drawings; another drawing in the Whitworth's collection is inscribed, in Walker's hand on the back, 'Ecstasy', whilst one in the collection of the Courtauld Institute Galleries is inscribed 'Aspiration'. Interestingly, Dobson also invested his female figures with symbolic qualities, but most of his represent what he described as the 'gentle virtues': peace, love, harmony, fruitfulness, contentment. The qualities which Walker frequently chose, by contrast, suggest activity and disturbance if not discontent. In the case of the pair discussed here, the significant difference between the two drawings would appear to be that Walker's placement of the figure on the page does not prioritise any part of the body around an assumed viewer; the figure shown whole, although temporarily still, retains the potential for movement which Dobson's figure lacks.

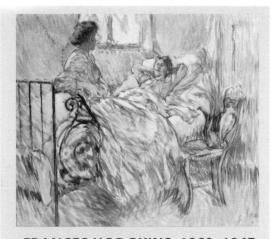

FRANCES HODGKINS 1869–1947
The Convalescent c.1912
Watercolour and charcoal
44.6 x 53.7 cm (D.1927.18)

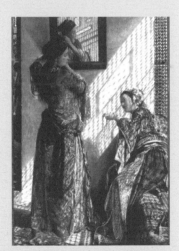

JOHN FREDERICK LEWIS 1805–76
Indoor Gossip, Cairo 1873
Oil on panel
30.4 x 20.2 cm (O.1961.1)

THERE ARE several striking similarities between these two works produced in different eras, one painted in Victorian England by an artist born at the beginning of the nineteenth century, the other probably painted in Paris by a woman who was only a few years old when the first work was produced. Nevertheless, both of them feature two women whose eye contact, gestures and body language suggest a moment of shared leisure and intimacy; furthermore, each features a window to one side of the figures, so that the play of light in the interior and over the women's bodies is an equally important aspect of the scene.

The technique of the two works, and the way in which these light effects are described, however, is strikingly different. Hodgkins uses a narrow range of colours which appear almost washed out by the light; Lewis uses a much wider range of brighter, denser colours which appear to be intensified rather than bleached by the light. These effects are linked to the medium used by each artist. Hodgkins has used watercolour, a translucent medium which, when applied to paper, allows the whiteness of the sheet to shine through in a way which can be especially effective with subtle, pale colours. She has also left a substantial amount of unpainted white paper visible between the brushstrokes, intensifying the impression that we, as viewers, are staring into a room filled with light, so that we have

to screw up our eyes to cope with its brightness. Lewis, however, has used oil paint, the density and opacity of which helps to suggest the richness and brilliance of the light reflected from the women's densely patterned clothing. He was especially interested in the effects of juxtaposed complementary colours (that is, colours which are furthest apart on the spectrum). Here the red/green and orange/blue contrasts on the sash of the standing woman and the layered skirts of the seated women further contribute to the intensity of the light effects.

What is especially interesting about this pair, however, is that Lewis has used oil paint in a manner usually associated with watercolour, whilst Hodgkins' technique is more frequently encountered in oil painting. Lewis had in fact spent much of the early part of his career working in watercolour, and when, around 1857, he began painting in oils, he worked in a manner strikingly similar to his earlier watercolour technique, showing a meticulous concern for detail as well as attempting to keep the surface of the oil paint absolutely smooth, without any trace of impasto (thickly applied paint). Frances Hodgkins, on the other hand, has used watercolour in quite a different way; whereas in Lewis' work it is impossible to see the individual brushstrokes with which it was painted, the separate strokes of Hodgkins' brush remain visible even from a distance in a way that resembles the oil painting technique

of Impressionist painters, especially Berthe Morisot, whose work Hodgkins must have seen whilst in Paris, where this watercolour was probably painted.

Lewis' work has frequently been discussed exclusively in terms of such matters of style and technique; the juxtaposition of his work with Hodgkins' shows up the inadequacy of such limited analyses. Most viewers shown this pair of works enjoy the effects of colour and light in the two works, but also want to know more about the implied narratives contained in each: what are the two women in Hodgkins' watercolour talking about? Who are the two women in Lewis' painting? Moreover, once they have examined both works for some time most viewers notice the shadowy third figure in Lewis' work, a woman in an inner room just visible to the left of the standing woman. She appears, in a rather disconcerting way, to be peering through a gap between the painted wall and the picture frame. At first she seems to be trying to look at the two women in the foreground, but it soon becomes clear that she could not hope to see them from where she is standing. Perhaps she is instead peeping at something or someone else standing in front of the two women; in which case she might be looking at the viewers of the painting – at us.

The question remains, however, as to who exactly is being addressed by the painting.

When it was first exhibited, at the Royal Academy's summer exhibition in London in 1873, it would have been seen alongside its pair, *Outdoor Gossip*; together these two paintings set up a contrast between the active, outdoor life of men and the secluded, indoor life of women in contemporary Egypt, a society in which the spheres of influence of women and men were even more rigidly separated than in the society inhabited by the middle- and upper-class viewers of the exhibition. Like many pictures of women exhibited at the Academy in the second half of the nineteenth century, it would appear that this painting addresses the male members of its audience, presenting them with a glimpse of a scene which in real life they would, both as men and as Westerners, have been doubly barred from seeing. Lewis' work appealed to male fantasies of the exotic, Middle-Eastern harem which had been stimulated in viewers in the Paris Salon as well as the London Academy by numerous images of bathers and 'odalisques', many naked or lightly draped, in sunny interiors filled with light and heat rendering them languorous and inactive, ripe for the sexual pleasure of their viewers.

However, the realism of Lewis' technique, which presents itself as a faithful transcription of every detail of an actual scene, belies the artificiality of the way in which it was constructed. Lewis had lived and worked in Cairo for ten years, but *Indoor Gossip* was

painted twenty years after his return to England, so that this work must have been based on sketches made decades earlier, perhaps supported by models, possibly including Lewis' wife, posed in his London studio. Contemporary reviews show that, by the time *Indoor Gossip* was exhibited, critics had begun to recognise these works as studio confections, and yet they continued to exert a powerful attraction, which must be understood not only in terms of Lewis' depiction of women, but also the fact that his painting was also part of the way in which 'European culture gained in strength and identity by setting itself off against the Orient as a sort of surrogate and even underground self.' (Said 1978:3). The style of Lewis' painting is vital in permitting a temporary suspension of disbelief, convincing viewers of the reality of a situation which is in fact pure fantasy: the fantasy of being allowed a glimpse of a secret, private world.

This is reinforced by the presence of the mysterious third figure. It now becomes clear that it is irrelevant who she is looking at; her function is to reflect what we, as viewers, are doing: standing, almost concealed from sight, and peeping at an entrancing scene. Although the figure is in such deep shadow that we can barely make out what she is wearing, we can, nevertheless, be sure that she is a woman, since all except one man and eunuchs were forbidden entry into the harem. However, if

she is to function as an echo and reinforcement of the activity of the viewer, this presents an odd situation.

The feminist theory of the 'gaze' would suggest that such paintings are addressed to the male gaze, constructing a viewer who stands in a relationship of power and dominance over the women depicted. A number of feminist writers have, however, more recently reconsidered this theory in an attempt to find a way of accommodating the viewing positions of those female members of both the audience of the painting when it was first exhibited, and its many subsequent audiences. Female viewers may be accustomed to responding to the use of male figures to suggest both genders, just as in speech and writing the male pronoun has, until very recently, been assumed to encompass both male and female. Here, however, we have a *female* figure being used either to represent both male and female viewing positions, or indeed the masculine viewpoint alone, if it is assumed that the painting's strongest appeal is to masculine heterosexuality. However, whilst female viewers may see themselves directly reflected by the figure of the third woman, many may nevertheless find it a discomforting experience. The women are so clearly presented to the enjoyment of heterosexual men, that heterosexual female viewers must either share in the pleasure thus created by imagining themselves as men, or imagine themselves as one of the women who are the instigators of this pleasure, or pay little attention to the subject matter and enjoy instead the colours and textures without reference to what they represent.

Frances Hodgkins' work, by contrast, would, if analysed in a similar way, be said to construct a viewing position which is both female and lesbian. It may well be for this reason that the watercolour was given the title *The Convalescent*. It is not known when this title was first used; similar works by Hodgkins are known by vaguer titles such as *Two Women in Conversation* (Sotheby's, London, 14.11.84, lot 117). It seems likely that this title was first applied to the painting not long after it had been bought for the Whitworth Art Gallery in 1926; if this is so it may have been a curator's attempt to provide an explanation for the two women being together in a bedroom, one which denied the possibility of a sexual relationship between them. The fact that it is possible to think of the painting in both ways is important. We may speculate that Hodgkins herself knew this watercolour could have two resonances, with the sexual one, the pleasure addressed to lesbian viewers, hidden, like the sexuality of most lesbians in the early decades of the twentieth century. However, such a possibility may well, at that time, have been sufficiently insistent when linked with the work of a female painter to warrant its active denial by the addition of a title which changed the bed from a site of sexual pleasure to the domain of an invalid.

2 Imagination, symbolism and the emotions

when the artist desires to soar a little above the passing moment ... he must use figurative language, and seek the beautiful and permanent images of emblematic design.

Walter Crane (Smith and Hyde 1989:23)

THERE ARE two sides to the question posed by this chapter. The first concerns the possibility that women experience life differently to men. Many of the visitors attending the workshops organised prior to the opening of the *Women and Men* exhibition felt quite strongly that most women shared certain characteristics, such as a greater susceptibility to emotional disturbance, which were not apparent in most men. This possibility brings with it a further question of particular relevance to the works discussed here. If art is the expression of feelings, or reflective of experience, and if women's experiences differ from men's, will it be, or has it been, possible for women to give shape to their feelings and experiences in visual languages primarily developed by men?

This question – whether women experience life differently from men and need to use different 'language' to express this in their art – is complex and has been much debated in the women's movement since the 1970s, with many differing opinions being voiced. The pairs of works discussed in this chapter suggest that it is undoubtedly true that the experience of living as a woman is different, primarily because in the modern Western cultures within which these works were produced the social, cultural and ideological factors shaping the lives of men and women

are different. Nevertheless, what is also clear is that all women do not share the same experiences, nor are these experiences uniformly opposed to those of men. There are some experiences which almost all adult women share: menstruation, for example. Childbirth is also an experience common to many, though by no means all, women. Nevertheless, it remains true that these experiences, like any other, are culturally negotiated. Menstruation and childbirth are treated and regarded differently at different times and in different cultures, and might therefore be experienced quite differently by women of different races or different social classes.

However, it remains true that what most women do share is the experience of living as women in a certain culture. Together they experience, and contribute to, ideas and beliefs about what women are, or should be, like produced and circulating in that culture. Their own, internalised beliefs about the kind of experiences and behaviour appropriate to their gender will also play a part. These ideas are not divorced from their social lives, but are linked closely to them; for example, the kind of clothing which is thought appropriate for women to wear in a given society can have marked effects on their physical movements, and therefore on their social behaviour and their relationships with other people. The cultural conditions in which women's lives are shaped inevitably affect the kind of art they might produce, though once again, this will not happen in any simple or uniform way, so that it will never be possible to enumerate a set of particular characteristics common to all women's art. However, the idea that there is something which can be defined and described as 'women's art', as opposed to 'art by women', remains surprisingly tenacious. Such beliefs were much in evidence in the summer of 1994, when the proposal to establish a Museum of Women's art in this country was being discussed. For example, Susan Wilson, a painter, lecturer and curator, felt that women's art could be defined as 'the instinct to decorate and embellish. I see it in my students' work. I see it in Paula Rego: an urge to tell stories, an urge to use detail' (Morrison 1994:18–19). Others, however, warned of the dangers inherent in such an approach, that 'insistence on these soft "feminine" qualities risks sending women's art back to the basement' (Morrison 1994:19). Whereas it might at times seem appropriate, for example, to denigrate Abstract Expression as 'art for boys', and to call for women's art – 'gentler, prettier, more domestic and accessible' (Morrison 1994:19) – to be reassessed and revalued, in the end this not only devalues art by women but also fundamentally misrepresents the variety of ways in which they have produced art.

Thus, although we may be wary of suggesting that it is possible to distinguish women's art from men's art by the identification of certain constant characteristics, it is nonetheless true that, in particular cultural circumstances, certain paintings could only have been produced by a man. Griselda Pollock has made this clear in her important work on painting in late nineteenth-century France. She points out that paintings such as *A Bar at the Folies-Bergère* (Courtauld Institute Galleries, London) or *Olympia* (Musée d'Orsay, Paris) could only have been produced by a male painter:

Would a woman of Manet's class have a familiarity with either of these spaces and its exchanges … ? Could Berthe Morisot have gone to such a location to canvass the subject? Would it enter her head as a site of modernity as she experienced it? (Pollock 1988:53–4)

Thus there clearly are differences – social, economic and subjective – between the experiences of being a woman and being a man in late nineteenth-century Paris, but these are not the result of any imaginary, fundamental biological differences between men and women, but the product of the way in which sexual difference is socially structured.

The other question, as to whether women can produce meanings in visual languages or codes which have been developed by men, is discussed in a number of different ways in this chapter. It would be wrong to suggest

that women have simply had certain formal codes imposed on them; women have been amongst those developing these formal languages, contributing to, and at times opposing or subverting, the ideas and meanings which can be conveyed through the dominant, masculine styles and imagery. Marianne Preindlsberger and Maria Cosway both use the language of allegory and personification fundamental to much of the history of Western painting, but they use it in order to put forward ideas about women's experiences and roles in society. Hannah Smith reworked actual examples of history painting into the needlework pictures on her casket, in the process significantly adding to the meanings they carried. Readers are asked to consider whether the use which these women made of the masculine traditions in which they were working suggests that they were constrained, or even indeed prevented from expressing ideas and feelings other than those for which this tradition had been developed. Käthe Kollwitz consciously deviated from certain aspects of the fine art tradition dominant in the culture in which she was working, choosing, for example, to work with black and white graphics rather than coloured oil paints. Nevertheless, since her work, in this and other ways, presented (and possibly still presents) a challenge to those people viewing it, readers might also ask themselves whether her attempt to undercut some of the values inherent in this tradition might not in fact have been less successful than some of the more subtle reworkings effected by Maria Cosway or Hannah Smith.

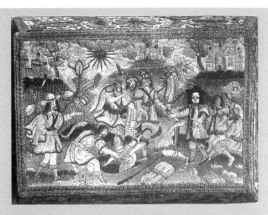

HANNAH SMITH b.1642
Hannah Smith's Casket 1654–56
Satin and canvas, embroidered in silks,
metal threads, purl, spangles and
seed pearls, attached to a wooden casket
30.5 x 17.7 x 25.5 cm (T.8237)

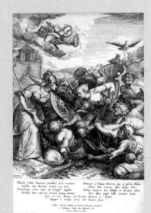

PIETER PERRET 1555–c.1625
after Otto van Veen
Minerva Protecting Youth c.1583–90
Engraving
32.4 x 22.2 cm (P.7076)

FEW PEOPLE will have had problems guessing that the embroidery, rather than the engraving, was done by a woman. Embroidery today is produced by few men on a professional basis, and fewer as amateurs. Embroidery has, in fact, been done by men at different periods in its history, especially on a professional basis, but by the mid-seventeenth century, when Hannah Smith's casket was produced, embroidery had become largely the province of women amateurs. One of the reasons for pairing these two works, however, was that both embroidery and engraving were widely regarded as having lesser status than the more prestigious public arts of painting, sculpture and architecture. The crucial difference between the two crafts was that engraving was rarely, if ever, carried out on an amateur basis; the skill of incising lines into copper printing plates was learned though a lengthy apprenticeship not normally available to women. Embroidery, however, was taught in domestic surroundings; learning to be a 'needle woman' (note that there is no masculine equivalent) was a fundamental part of a young girl's education.

The subject matter of the oil painting which the engraver has reproduced deals with conventional ideas in a very traditional way. The female figures personify qualities associated with the choices confronting a young man entering adult life. He is shown prostrated on his back, whilst women representing the different concepts he must choose between are shown literally fighting over his body. The struggle between living a life of virtue and a life solely dedicated to pleasure is in part represented by the landscapes in the background of the print. That on the right, behind the representatives of pleasurable self-indulgence, is lush and tree-lined, whereas that on the left shows a barren, rocky path up a very steep incline to the Temple of Virtue. In the foreground the forces of temptation greatly outnumber those representing virtue. Venus, Roman goddess of love and fertility, has arrived in her scallop-shaped chariot with her traditional accompaniment of two doves, and begun to squirt milk from her breast into the mouth of the prostrate youth. Venus' traditional companion, Cupid, helps by turning the young man's head in the direction of the jet of milk, whilst behind Venus are Bacchus and Ceres, offering further temptations of the flesh. Opposing Venus and her companions is Minerva, goddess of wisdom, who valiantly tries to raise the youth up from the floor with one hand, whilst with the other interposing her shield, with its serpent-haired head of Medusa, between the milk and the youth's open mouth. Between the two warring groups is Time, represented by an old man, who gestures with his scythe towards Venus, in a traditional reminder of the fleeting nature of earthly delights.

This print then, is an example of the conventional use of emblematic and symbolic figures to suggest traditional concepts. Perret did make some alterations to the painting he was copying, but these neither changed nor added significantly to the meanings of the image. Smith, by contrast, through her selection and combination of images, and by slight alterations to the originals, has loaded them with additional meanings appropriate to her own personal and political situation. We know that the casket was embroidered by a twelve-year-old girl named Hannah Smith since she recorded this in a letter found in one of the drawers. This letter also records that the embroidery was done in Oxford between 1654 and 1656, and shows, as Rozsika Parker has pointed out, 'how important [such] needlework projects were to the children who carried them out, how closely bound in with the project was the child's sense of self' (Parker 1984:87–8). Smith's gender was clearly vital to her sense of self. Of equal importance, however, was her own political situation, the very nature of which, as we shall see, meant that some of the meanings contained in her work had to be expressed in a covert way, to be kept hidden from anyone except a small group of fellow sympathisers. They appear to have remained hidden until now.

It cannot be without significance that the unusual biblical scenes which Hannah Smith chose to embroider represent unusually powerful actions by women, such as Jael, a Jewish heroine represented as a saviour of her race. The researches of both Rozsika Parker and Griselda Pollock have shown that, from all the biblical subjects available to them, many women painters and embroiderers chose Old Testament heroines such as Judith, Jael and Deborah with significant frequency (Parker and Pollock 1986:20–7; Parker 1984:98–102). However, it seems clear that Hannah Smith chose these scenes because they could convey meanings not only appropriate to her gender but also to her political situation. The fact that the embroidery was done in Oxford between 1654 and 1655 suggests that Smith may have had Royalist sympathies which, since the embroidery was started during the Commonwealth, in the year following Cromwell's dissolution of Parliament, and five years after the beheading of Charles I, it was prudent to keep hidden.

Smith has, nevertheless, included two Royalist symbols – the lion and the leopard – on the front of the box, either side of the key. These animals, which are given particular emphasis by being executed in raised stump work, literally provide the 'key' to the interpretation of the scenes below: 'Deborah and Barak' and 'Jael and Sisera'. These two related scenes show an oppressed minority, the Jewish people, being saved by God working through the agency of the heroic actions of two women.

On the left, the prophetess Deborah is telling Barak to lead an army against Sisera, captain of the forces oppressing the Jews in Canaan. Barak agrees on condition that Deborah accompanies him; this she does, although warning him that he will be dishonoured if God delivers the enemy Sisera into the hands of a woman. Sisera is defeated in the ensuing battle, and flees to the tent of Jael who, as shown in the scene on the right, kills him by driving a nail through his head as he sleeps.

Hannah Smith, it seems, intended to imply a parallel, to be recognised by fellow Royalist sympathisers, between the situation of the oppressed Jewish people in Canaan and that of the Royalists under the protectorate. This is confirmed by analysis of the scene on the lid of the casket which, from the technical complexity of its execution, and the quantities of expensive metal threads and seed pearls used in it, would appear to be the most important of all the embroidered panels. It shows Joseph being raised from the pit and sold by his brothers to the Midianite merchants, a story of the betrayal of a boy appointed by God to be a leader of the Jews. This composition was copied by Hannah Smith from an engraving in a sixteenth-century book of biblical illustrations, published by Gerard de Jode (Harris 1988:53–4). Smith has not, however, copied the scene exactly; one of her main alterations is the addition of a figure to the right of the group around Joseph, whose

identity has caused some confusion. He is clearly an important figure, not only specially added to the composition, but also given extra emphasis, along with the lion and the leopard, by being executed in raised or padded stump work. The other characters in the scene have been executed in a variety of other stitches, such as tent stitch, which lie flat against the canvas ground; they are, literally and figuratively, less prominent. This additional man has been identified as Joseph, presumably because he is the most prominent figure. Joseph, however, is clearly the boy being taken out of the pit, and although such scenes do sometimes feature the same person at different stages of the narrative, there are significant differences between the two men which seem to suggest that if the larger figure does represent Joseph, it is Joseph transformed or reborn. The link between this stump work figure and the Royalist symbols furthermore suggests that his function may be to draw the attention of sympathetic viewers to the parallel situations of Joseph and Charles I, both of whom were men intended by God to be leaders of their people, but who were exiled. In this case, Charles I could be seen as Joseph reborn, expressing the hope that, like Joseph, kingship (if not an individual king) will survive its present persecution.

This interpretation is supported by Smith's inclusion of further symbols of kingship and Royalist sympathy: the sun, the butterfly and the caterpillar. The sun was a traditional symbol of the God-given right of the king to rule. In this scene it is shown partly obscured by a cloud, suggesting that as, in the nature of things, the sun will eventually come out from behind the cloud, so this period in which England is without a king will come to an end. The caterpillar and the butterfly were also used by Royalists to express the hope of the return of the monarchy, suggesting that one king never dies without being replaced by another, in the same way that the butterfly emerges from the chrysalis created by the caterpillar. Hannah Smith's casket was in fact finished four years before the Restoration.

Being in a position of economic dependence, the engraver Pieter Perret was unlikely to subvert or even substantially alter the works he reproduced. Working outside the cash nexus to produce an object for private use, Smith was able, through the selection and reworking of the pre-existing designs which she reproduced, to create an object which held for her a particular meaning of great importance. Whilst the imagery of the scenes gave hope to the exiled Royalists, the representation in delicate needlework stitches of such violent events as Jael's killing of Sisera also expressed the contradictions inherent in the situation of young women in mid-seventeenth-century Britain. Within the confines of a needlework project intended to confirm her entry into womanhood and femininity, Hannah Smith has created a work which also asserts the great potential of her gender.

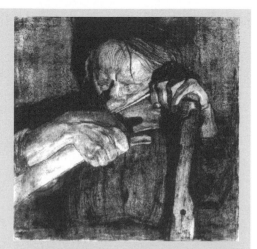

KÄTHE KOLLWITZ 1867–1945
Whetting the Scythe 1905
Etching and engraving
59 x 43.7 cm (P.22458)

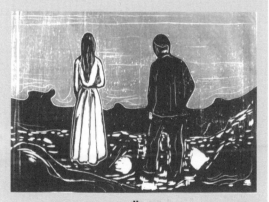

EDVARD MÜNCH 1863–1944
Two People – The Lonely Ones
1899
Woodcut, printed in two colours
39.4 x 54.7 cm (P.22685)

THESE TWO prints were produced only six years apart by two artists both of whom are now regarded as being important figures in the history of modern art; their subject matter is, nevertheless, tellingly different. Münch's work deals with personal suffering in human relationships; Kollwitz's print is one of a series dealing with the widespread poverty and oppression, and the subsequent peasants' uprising, in Germany in the early sixteenth century. A feminist art historian, discussing Münch and Kollwitz's work, has contrasted 'the male who grieves for himself and the female who grieves for humanity' (Comini 1982:271). The question here is whether such a distinction has any validity wider than its immediate application to these two individual artists, indeed, to these two individual works? Furthermore, will this distinction be apparent to late twentieth-century viewers of these images?

In the discussion groups held prior to the opening of the *Women and Men* exhibition, over half the people shown this pair of prints thought that Kollwitz's work was by a man. Several of the viewers also thought that the figure represented in it was a man. When told it was a woman, most of them described feeling quite unaccustomed to seeing images of physically powerful women in an equally powerful and dramatic context; many of them pointed in particular to the broadness and muscularity of the figure's right arm, which

they instinctively felt must belong to a working man. In fact the woman is a historical figure, a peasant woman known as 'Black Anna', who played a vital, activist role in the German uprising of 1522–25 which is the focus of the series of seven prints, *Die Bauernkrieg* (The Peasants' War), to which *Whetting the Scythe* belongs. It has also been suggested that Kollwitz identified herself with Black Anna, telling her biographer that she 'had portrayed herself in this woman' (Nochlin 1991:23).

The unsettling, threatening atmosphere of the print is largely created by the use of dramatic lighting, emphasised by the rich black shadows created by the mixture of intaglio processes which Kollwitz has used. Kollwitz's decision for the most part to eschew the use of colour, and its associations with sensual pleasure, in her work, and to concentrate instead on the effects achievable by the use of black marks on white paper, is richly justified by the power of this image. The dramatic play of light on the woman's brooding features, emphasised by the dark shadow behind her which creates a sort of halo in reverse, and the lighting of her hands and muscular arm as she grips the scythe she is sharpening, forces the question 'What (or who) is she going to cut down?'. Indeed, the very fact that the figure *is* a woman rather than a man, as a viewer might have expected, emphasises the 'world-turned-upside-down' effect of peasants rising against

their masters. The normal social order is inverted, so that ordinary implements of husbandry and agriculture are used for warfare and destruction rather than cultivation, and women take on masculine roles, destroying rather than nurturing life.

The 'world-turned-upside-down' theme had two main aspects: Twelfth Night and other celebrations often involved masters and servants changing places, a carnivalesque inversion which nevertheless reinforced the distinctions temporarily overthrown; there was also a rich vein of folklore traditions warning those who might be tempted to disrupt the social order. Across Europe and into Russia, popular satirical prints of women dominating, instead of being dominated by, their husbands, scornfully ridiculed such folly as a transgression of the natural order, heralding the unleashing of uncontrollable chaos. It is significant, then, that Kollwitz chose to set her apparently unprecedented images of powerful women in the context of social disorder and political upheaval. Linda Nochlin has argued that Kollwitz deliberately took the negative associations of female assertions of power

and made them into positive if frightening visual signifiers. The dark, chthonic force associated with the peasant woman, those malevolent, sometimes supernatural powers associated with the unleashing of feminine, popular energies and not totally foreign to the most menacing of all female figures –

the witch – here assumes a positive social and psychological value: the force of darkness, in the context of historic consciousness, is transformed into a harbinger of light. (Nochlin 1991:25)

The strength of the traditional associations of powerful women with chaos and destruction should not, however, be underestimated. Many participants in the workshops prior to the exhibition, far from seeing this as a positive image, a 'harbinger of light', described feeling repelled by Kollwitz's print, so thoroughly did it overturn their expectations about representations of women in art.

At the time of making this print, Käthe Kollwitz was a socialist, a feminist and a pacifist, committed to using her art as a vehicle for radical social comment. However, because she chose to work in a realist, rather than a more avant-garde style, and because she chose printmaking and drawing rather than more prestigious media such as oil painting or sculpture, later art historians, disturbed by the fact that Kollwitz made posters for the communist cause in the immediate post-war years, tended to dismiss her work as 'propaganda' and illustration. Her work has thus only recently begun to be reassessed and revalued by (mainly feminist) art historians. It is now clear that it was a deliberate choice on Kollwitz's part to reject the expressions of individual torment which had marked the work of her male contemporaries such as Münch and Ensor, and

which soon came to dominate the Expressionist movement. Kollwitz came to see Expressionism as studio-based, cut off from social reality. Three years after the publication of this print, she wrote in her diary, 'I am convinced that there must be an understanding between the artist and the people such as there always used to be in the best periods in history.' (Chadwick 1991:274).

Münch's *Two People – The Lonely Ones* thus represents the kind of image from which Kollwitz wanted to distinguish her own work. Münch has used a particular landscape which had very personal associations as the background for this woodcut which deals, like many others in his *oeuvre*, with the theme of the sadness and isolation caused by sexual jealousy. During the 1880s, Münch regularly spent his summers in a cottage in a fishing village on the Norwegian coast at Asgardstrand; the rocky beach and the gently curving shoreline of the area are used in this print not only to provide a setting for the figures but also to suggest something of their states of mind. The rocks suggest intractable problems, pain and difficulties, whilst the sea seems to threaten to engulf the two figures, whose suffering and isolation seem all the more palpable because they have turned their backs towards us. The physical distance between the two figures also suggests their emotional and spiritual distance and discord; indeed the particular printmaking technique which

Münch used was well calculated to suggest isolation, since it involved literally cutting around the outlines of the figures, dividing up the wooden printing block like a jigsaw into separate pieces which could be individually inked in different colours; the inked sections were then fitted back together again so that the complete block could be printed in two colours at once. Unlike Kollwitz, however, the limited use, or complete rejection, of colour was not a common feature of Münch's work; nevertheless, the use of two cold colours is a further means of suggesting a negative emotional mood.

A distinction, however, is made between the male and the female figure: whereas the woman faces away from us, and appears perfectly self-contained, the man's head and body are turned slightly at an angle, so that he appears to be trying to take a step towards her, though the rocks and the sea intervene. This fact encouraged many of the participants at the preparatory workshop at the Whitworth to discuss the relationship between the two figures, and to wonder whether blame for the apparent discord was being laid at the feet of the woman, since she appeared to them to be repulsing the tentative advances of the male. This made some of the male viewers feel angry, whilst some of the female viewers, on discovering that the artist was male, felt that it was only to be expected that he should show either himself personally, or his gender in general, as the injured party, and that the woman/female gender should be shown as at fault.

These responses to both images may or may not be typical or representative of any wider group of late twentieth-century viewers of these prints. What they do illustrate, however, is the complexity of gender issues which are brought into play by the process of examining a historical work of art. The gender of the artist/producer(s), the gender of the figure(s) represented, the viewer's interpretation of the gender represented (which may not be the same thing), and the gender of the viewer all create an interplay of forces as complex as it is unpredictable. In this case it is noteworthy that the work of an artist heralded by a late twentieth-century feminist art historian as having 'attempted to challenge the assumptions of gender ideology, piercing through the structure of symbolic domination with conscious, politically informed awareness' (Nochlin 1991:23), will not necessarily be attractive to late twentieth-century female viewers, feminist or otherwise.

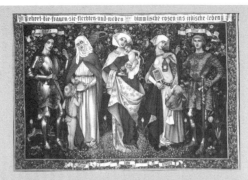

MARIANNE PREINDLSBERGER (STOKES) 1855–1927
Ehret die Frauen (Honour the Women) 1912
Tapestry, woven by Martin and Berry at Morris & Co., Merton Abbey
177.8 x 254 cm (T.1975.124)

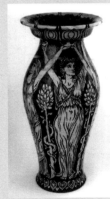

WALTER CRANE 1845–1915
Vase with Female Figures c.1888–9
Earthenware, painted in ruby lustre on a cream ground, manufactured by Maw & Co.
Height 30.5 cm On loan from Manchester Metropolitan University

THE ISSUE repeatedly raised by the pairs in this chapter is whether it is possible for women artists to create their own meanings in languages which have been created by men. This was especially problematic for women artists trying to use the language of allegory and symbolism in which female figures were traditionally used to represent concepts such as 'truth' or 'vanity'. Prior to the nineteenth century, women artists (painters and, to some extent, writers) who wished to deal with abstract ideas such as 'liberty' or 'justice', had little choice but to represent such concepts by figures of their own gender. This caused two problems: firstly, the female form was used to represent concepts such as 'liberty' which could evoke a wide range of associations, many of which were far from the experience of women themselves; secondly, any attempt to dramatise their own experiences using this language forced women artists to depict themselves interacting with figures who, though they appeared similar, were intended to function in quite a different way. By the late nineteenth and early twentieth centuries, when these two works were produced, the language of allegory had been challenged by generations of artists trying to forge new ways of producing meanings more appropriate to the modern world. Nevertheless, personification was not, indeed has still not been, completely excluded from the language of art, and these two works show the problems encountered by both male and female artists attempting to work within a tradition faced by many challenges.

The tapestry *Honour the Women* was designed by Marianne Preindlsberger, although it was woven by men employed at the Merton Abbey works of Morris and Company; Preindlsberger was one of a number of artists commissioned to produce designs for the company after the death of Edward Burne-Jones. In designing this tapestry Preindlsberger used both male and female figures to express the concepts central to her theme, although she was clearly more at home working with female figures; the numerous oil paintings which she exhibited during the early years of this century for the most part contained either religious figures such as the Virgin Mary or female saints, or portraits of women, genre figures of young girls, or female figures personifying concepts such as *primavera* (spring).

Preindlsberger was one of a number of Victorian women artists whose marriage to a male artist (she married the painter and critic Adrian Stokes in 1884) enabled them to continue to work and exhibit rather than giving up these activities to concentrate on the care of children, home and husband. Modern critics, however, have been quick to connect the recurrence of young girls in Preindlsberger's work with the fact that she herself remained childless, mainly because this seemed to add

an extra dimension of emotional stress to her depictions of women and children together, such as the central three figures in the Whitworth's tapestry. What seems to me more interesting, however, is the fact that the two outer figures in the tapestry are men. It is surely significant that, when deciding how to represent a number of different abstract qualities, she chose to represent 'care', 'love' and 'knowledge' by female figures, and 'protection' and 'faithfulness' by male figures. In other words, in representing the concepts by women and men performing their traditional 'feminine' and 'masculine' duties, Preindlsberger has undermined the potential allegorical function of the figures. As Marina Warner has made clear, such references to the actual roles performed by women can sit uneasily with the allegorical mode, which in many ways relies on the dissimilarity between the concepts represented and the figures in which they are clothed:

Justice is not spoken of as a woman … because women were thought to be just, any more than they were considered capable of dispensing justice. Liberty is not represented as a woman … because women were or are free. Often the recognition of a difference between the symbolic order, … and the actual order … depends on the unlikelihood of women practising the concepts they represent. (Warner 1996:xix)

It seems likely that Preindlsberger was attempting to dignify the role of women in contemporary society in a number of different ways. Firstly, she suggests that the roles of childbearing, nurturing and teaching that women perform are amongst the most important that the human race can carry out. Secondly, she does this not in a small genre painting in watercolour, as Emily Farmer (see p. 86) and many other artists had done before her, but in the form of a large tapestry designed to hang in a public place. Furthermore, she uses the language of personification which many continued to see as the only satisfactory way of indicating the expression of a high moral purpose. However, by representing the roles of women by female figures, and the duties of 'protection' and 'faithfulness' expected of men by male figures in armour flanking the women and children, Preindlsberger has ensured that they no longer contribute to the construction of an allegory, a narrative which represents a theme or idea in a veiled form, like an extended metaphor. Instead they simply appear to be performing their 'natural' duties (albeit in fancy dress) as emphasised by the title, *Honour the Women*, a command addressed to a male audience.

The problems which Preindlsberger experienced with the use of allegorical figures were, however, by no means exclusive to women artists. Having worked early in his career under the influence of the naturalist aesthetic of the pre-Raphaelites, Walter Crane later experienced a growing dissatisfaction with what he referred to as 'literalism'. He, too, came to believe that the symbolic mode was superior in that it stemmed from imagination rather than observation, arguing that

when the artist desires to soar a little above the passing moment to suggest the past, to peer into the future … when he would deal with the thoughts of man's origin and destiny, of the powers and passions that sway him, of loves, of hope and fear, of the mystery of life and nature, … he must use figurative language, and seek the beautiful and permanent images of emblematic design. (Smith and Hyde 1989:23)

Nevertheless in trying to forge a visual language which was at the same time full of potent symbols yet widely intelligible, Crane frequently produced paintings containing imagery which was at best simplistic and at worst crass, such as his painting of the sea shore where the waves appear in the shapes of white horses (illustrated in Smith and Hyde 1989:19).

It was in the decorative arts that Crane's use of symbolic imagery and personification was more successful. Even in this he was going against an increasingly accepted view, most clearly articulated by Lewis F. Day, that decorative art should not be 'over-burdened' with meaning or symbolic figures. However, in the series of vases to which the example discussed here belongs, Crane produced a number of playful variations on the

relationships between the shapes of the vases and the painted decorations which they carried, involving in one case a vase in the form of a ship with two handles representing the ship's prow in the form of a swan's head and the stern in the form of a fish's tail. On this example the painted women are carefully positioned so that their bodies appear to echo the shape of the 'body' of the vase, the widest point of which is at the same height as the women's breasts. It remains unclear exactly what these women represent; it is possible that their conjoined hands supporting lighted oil lamps contain a reference to a higher type of knowledge, more positive than the evil kind represented by the motif of the entwined serpents gliding around the tree of knowledge repeated between them.

The use of such indeterminate figures may have been acceptable for the decoration of a vase, but it was not something that, according to Crane's aesthetic, could be applied to painting, where the need to read an allegorical 'message' into the figures is paramount. However, the area of Crane's work in which he used allegorical figures with most success, and the field within which allegory is still most frequently encountered in Europe and North America in the late twentieth century, is that of the political cartoon. Crane developed a cast of female allegorical figures to represent concepts such as 'liberty', 'unity' and 'peace' which he used repeatedly in cartoons for magazines and newspapers such as *Justice* and the *Daily Chronicle*. (Negative concepts, such as 'capital', were frequently represented by bloated male figures.) The effectiveness of these images was demonstrated by their remarkably long lifespan, many continuing to be reproduced or reworked well into the twentieth century; indeed, Steve Bell has referred to them as recently as 1994. This effectiveness was, however, also dependent on the willingness of Crane's audience to read such female figures in a positive light, as representative of forces for good. At the other end of the twentieth century we are more likely to encounter such female allegorical figures in satirical cartoons, such as the famous image of Margaret Thatcher as Britannia, where the difference between the individual woman and the allegorical character in which she was cast was used to ridicule not only the woman herself and her imperialist ambitions, but also the language of personification itself.

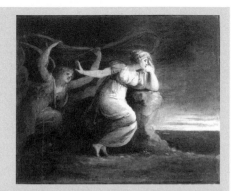

MARIA COSWAY 1760–1838
Illustration to the Ballad in 'Indiscretion': Woman by the Sea Repelling the Spirit of Melancholy?
*c.*1800
Oil and pen and ink on paper
19.1 x 23.4 cm (D.1946.2)

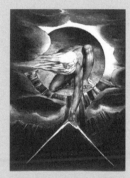

WILLIAM BLAKE 1757–1827
Frontispiece for 'Europe: A Prophecy': Urizen Creating the Universe? 1824/27
Watercolour and bodycolour, black ink and gold paint over a relief etched outline on paper
23.2 x 17 cm (D.1892.32)

I N MANY ways this pair should be one of the easiest to guess, partly because Blake's image is so famous, but also because both artists have painted figures of their own gender which appear to conform to traditional stereotypes: the male artist has produced an image of awe-inspiring male power and domination, whilst the female artist has produced an image of female weakness and emotional disturbance. The question remains, however, as to whether this means that these images are simple reflections of the artists' own experiences, suggesting to us what it was like to live as gendered beings in a particular historical culture, or whether they function in a more complex way which deserves further investigation.

In fact, neither of these images stands alone; both relate in different ways to poems. Maria Cosway's painting was produced as the design for a print; it still bears indentations around the outlines of the figures where a stylus or similar implement was pressed into the paper in order to transfer the lines onto a grounded plate beneath, which could later be etched and printed. The print was one of a set of four published by Rudolph Ackerman, and sold for 3s 6d each printed in black only, or 7s in colour. The prints illustrate a ballad written by Dorothea Plowden and sung by the celebrated actress Dorothy Jordan in the play *Indiscretion*, written by Prince Hoare and first performed in 1800. Blake's work is itself partly

printed; uniquely at the time, he produced 'editions' of illustrations for his poems by printing a slight outline of the image and then completing them by extensive painting over the printed lines. However, it remains uncertain as to whether this image should properly be described as a frontispiece for *Europe: A Prophecy*, first published in 1794, since it differs in size from the rest of the illustrations, and this particular version of the image was produced separately from the book, since it was hand-coloured in either 1824 or 1827 (it bears a date which can be read either way) over a printed outline probably produced over three decades earlier.

The question remains as to whether the ease with which we can detect the woman's work here means that these paintings are direct reflections of the artists' experiences as gendered beings. The immediate answer is, of course, that there is no such thing as a 'direct reflection' of experience; artists always have to translate experience into another form, be it words, music or images, and can only communicate by using and developing the formal codes established within that medium. In this case, both Cosway and Blake are using traditions established within European figure painting to enable them to use human figures to represent ideas or emotions rather than specific individuals; Cosway's winged female figure dressed in blue robes, for example, has been seen as representing the state of

melancholy, the shadowy net which she is about to cast over the seated woman suggesting the way in which feelings can threaten to engulf a person in despair.

However, even though these works are clearly not direct reflections of experience, we may still ask whether the artists' experiences as gendered beings nevertheless informed the language of representation which they chose to use. The fact that so much is known about Maria Cosway's personal life makes it tempting to use this knowledge to inform readings of her work. We know, for example, that she went through many experiences likely to cause extreme psychological disturbance: her four elder siblings were all murdered by their wet-nurse, and, later in life, her own pregnancy and the birth of a daughter in 1790 endangered her life and caused her so much distress that she left the baby and her husband in England whilst she went to France to recover. For reasons not entirely clear, she then stayed in Italy for four years, living for part of this time in a convent, and did not return until her daughter was over four years old. Only two years later the child died (Lloyd 1995). It is not difficult, then, from even this brief summary, to read into this image a reflection of the artist's own sufferings and struggle against depression.

The fact that this painting was part of a project involving, unusually for the time, the collaboration of three women – a writer, an actress and an artist – suggests further that their intention may have been to dramatise experiences common to their gender. The full text of the ballad is as follows:

I rise with the morn, I gaze on the sun,
Aurora's bright lustre I see;

But I sigh with regret when daylight is gone,
For night brings no comfort to me.

I wander at night where the nightingales sing;
I traverse the sands of the sea;

They hear not my sighs, so no comfort they bring,
For what can bring comfort to me.

(*Monthly Magazine*, 1801)

There has been some confusion over which of these lines is illustrated by the Whitworth's painting, since an impression of the print which follows it is numbered 'verse 4', whereas a contemporary newspaper critic describes it as illustrating the second verse, by which account the allegorical figure represents not melancholy but night with her 'sable robe' (*Monthly Magazine* 1801). What is clear, however, is that another of the images, the preparatory painting for which is also in the Whitworth's collection, shows a female figure dancing by the sea by the light of the moon. This leads to the possibility that the association of female depression with the moon refers to the traditional linking of women with the pale light of the moon and with Diana the Huntress, as opposed to the strong daylight of the sun, represented by the god Apollo. This pairing may in turn reflect masculine fears and uncertainties concerning female menstruation, the monthly cycle of which was thought to be related to the waxing and waning of the moon, and the associated idea that women were moody and unpredictable in the same way as the light of the moon was thought to encourage instability and lunacy. Since Maria Cosway appears to have suffered severe post-natal depression, which is commonly experienced by women who also suffer premenstrual syndrome, we might be tempted to suggest that this image had a particular personal significance for the artist herself as well as for her own gender as a whole.

Such interpretations are dangerous, however, since they can encourage belief in an unchanging female nature that is not affected by differing historical and cultural circumstances; in this particular instance, such a reading could bolster claims that women have always been ruled by the biology of their bodies, and are therefore incapable of producing art that transcends their biological nature in the way that Blake's image might be thought to do. We, as late twentieth-century female viewers of Cosway's painting, may well wish to see in it a direct reflection of our own experiences of the mental distress which can precede menstruation. However, we should not deduce from this that we can therefore immediately understand either

Cosway's life or work; indeed, what information we do have about late eighteenth-century British society in general, and the lives of Maria Cosway and her husband in particular, suggests that the cultural construction of gendered beings differed radically from that in late twentieth-century British society.

The multitude of different cultural and social tensions affecting the way in which masculinity was defined and experienced in the late eighteenth century is well illustrated by the career of Maria's husband, Richard Cosway. Richard was also an artist, and his successful career was built largely on his success in maintaining the patronage of royalty and the aristocracy. His own social persona, however, was that of a gentleman earlier in the century; much of his extravagantly elaborate clothing, decorated with embroidery and lace, was not only anachronistic but increasingly out of step with the general tendency of men's clothing towards sobriety in both fabrics and colours. He also wore a sword, a habit which had fallen into disuse during the middle decades of the century; its revival by fashionable gentleman like Cosway was the source of constant ridicule as such men were widely seen as being too effeminate actually to use such a weapon. In Cosway's case this was compounded by the fact that the wearing of a sword had earlier been confined to the highest social elite, so

that many saw it as extreme social pretension for a mere artist to adopt the habit.

By contrast, Maria Cosway's experiences as an artist demonstrate the widely differing ways in which femininity was defined and experienced. Maria Cosway was regarded by her contemporaries not as a professional artist but as an 'accomplished woman'; to work as a professional earning money from her art would have compromised both her femininity and her social standing. However, the mere fact of not being able to work professionally affected the quality of her work. Deprived of any incentive to finish her paintings, she found it impossible to maintain her own standards: 'had Mr C[osway] permitted me to paint professionally, I should have made a better painter, but left to myself by degrees, instead of improving, I lost what I had brought from Italy of my early studies' (Williamson 1897).

It is especially difficult to interpret Blake's work without further knowledge about the artist; unlike Cosway's work, Blake's image does not depend on established conventions traditionally used for such figures. Usually called either *The Ancient of Days* (a title invented by J. T. Smith in 1828) or *God Creating the Universe*, this work, one of the most widely admired and frequently reproduced in British art, is popularly seen as a celebration of primal, masculine power and

creativity; the mastering of chaos by a divine order. However, most academic authorities on Blake agree that his intention was to invert these attitudes. Blake invented an alternative mythology peopled with figures such as 'Urizen', who may be shown here, representing reason as a negative, oppressive quality, gendered as male; imagination, however, was for Blake a positive quality gendered as both male and female.

3 Gender and creativity

Women, in general, possess no artistic sensibility ... nor genius.

Jean Jacques Rousseau (Battersby 1989)

ONE OF the main reasons that Linda Nochlin wrote the essay 'Why have there been no great women artists?' (Nochlin 1991: 145–78), now seen as seminal for the study of women's art, was to refute the suggestion that the answer to this question was that greatness stemmed from innate qualities or 'genius', which were absent in women. Accepting that there had been a difference in quality between art produced by men and that by women, Nochlin was nonetheless determined to prove that the reasons for this lay in social and institutional, rather than biological, realms. She believed that there was nothing inherent in women's makeup rendering them incapable of the highest forms of creativity. To this Germaine Greer added (Greer 1979) the ideological realm, the internalised forms of repression to which women were subject as they negotiated current ideas and beliefs about the kinds of behaviour appropriate to their gender. However, by the early 1980s, Rozsika Parker and Griselda Pollock felt it necessary to warn that 'to see women's history only as a progressive struggle against great odds is to fall into the trap of unwittingly reasserting the established male standards as the appropriate norm' (Parker and Pollock 1986:xviii). They argued that we must instead look at the specific ways in which, in spite of these difficulties, women have nonetheless made art, as well as acknowledging that factors such as

social class have affected their work as much as gender.

Some twenty years after Nochlin's essay, sufficient painstaking work has been done by a number of art historians to recover and analyse the work of countless women artists, so that we can with confidence say that the work of Berthe Morisot, Rosa Bonheur, Gwen John, Käthe Kollwitz and others demonstrates that there *have* been great women artists. Even so, it is also true that many feminist art historians, heeding the warning given by Parker, are wary of using the kinds of analyses and value judgments used to create notions of 'great' male artists, since these were the very methods by which women's work was categorised as separate, and second rate, in the first place. Christine Battersby's history of the concept 'genius' has shown the implicit and explicit gender bias of this notion (Battersby 1989), which is well demonstrated by the continuing use of the imagery of fire to symbolise creative forces. Long after the notions that that males were associated with heat and dryness, and females with cold and dampness, had been scientifically refuted, this imagery continued to be used to embellish claims that women were incapable of reaching the heights of creativity. By the eighteenth century women were no longer seen as underdeveloped men, lacking the heat necessary for their reproductive organs to grow outwards so that they remained undeveloped inside their bodies; nevertheless Rousseau could still suggest that:

Women, in general, posses no artistic sensibility … nor genius … the celestial fire that emblazons and ignites the soul, the inspiration that consumes and devours … these sublime ecstasies are always lacking in women's writing. These creations are as cold and pretty as women. (Jean Jacques Rousseau [1758], quoted in Battersby 1989:50)

It would be simplistic to see this as an ideology imposed on women by men. During the latter half of the eighteenth century, debates about whether women's and men's creativity were inherently different, in both character and quality, raged on both sides of the channel, and it was not only men who argued that women were by nature fit only for certain tasks. The conservative writer Hannah More believed that women

excel in details; but they do not so much generalise their ideas as men … A woman sees the world, as it were, from a little elevation in her own garden, where she makes an exact survey of home scenes, but takes not in that wider range of distant prospects which he who stands on a loftier eminence commands. (More 1799:22)

The aim of this chapter is to ask readers to examine their ideas about gender as one of a number of possible factors affecting creativity. Paired in this section are works from widely different cultures, works produced by men and women working in collaboration, and works which are copies of other works, an activity frequently thought to require an attention to detail combined with a lack of inspirational fire which women were said to be particularly suited to provide. There is also a work by an artist who was convinced that the biological differences between men and women meant that only men were capable of the highest forms of creativity; that any creativity which women might posses was derived from 'frustrated maternity' and therefore limited. This male artist was convinced that the urge to higher forms of artistic creation comes from male sexual energy; if he was right, it should be easy to distinguish his work from that of the female artist with which it is compared. Readers are left to answer this question for themselves.

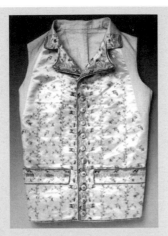

ANONYMOUS BRITISH WOMAN
Embroidered Waistcoat c.1790
Silk satin embroidered with coloured silks
Length 57, circumference 94 cm (T.12249)

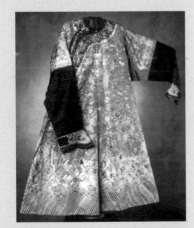

ANONYMOUS CHINESE MAN
Mandarin's Robe early 19th century
Satin weave silk embroidered
with silk and gold thread
Length 147.3, circumference 226 cm (T.8902)

THESE TWO WORKS have been juxtaposed in order to question the effect which widely differing cultural contexts might have both on the ways in which the production of such objects is organised, and on the response which readers might have to them, particularly if that reader is more familiar with the cultural context of one object than another. There are two reasons for choosing to discuss these issues in the context of textiles. The first is that only in the textile collection at the Whitworth are objects from non-European cultures well represented. In the early decades of the Gallery's history an intention was formed to collect examples of both fine and decorative arts from all over the world, but this aim was gradually lost in the fine art department, which now collects art from only Europe and America, and mostly from the eighteenth century to the present day. The textile department has, however, continued to cover the history of textiles produced all over the world from the fourth century to the present day; the fact that there has, until the early 1990s, been only one member of staff in the textile department with the task of researching this huge amount of historical information, whilst in the fine art department there were three people covering a much smaller area, speaks volumes about the relative importance which museums continue to attach to art in which men have been the dominant producers, as opposed to that which has in many cultures and at many historical periods been predominantly the province of women.

The second point is more complex. Much of the discussion amongst feminists during the 1970s and early 1980s centred around the question of essentialism, or biological determinism: is it true that there are aspects of the biological nature of women, connected with their ability to give birth, that ensure that all women of whatever racial or cultural background, and at whatever historical period, have certain things in common? As far as art is concerned, any reader of this book who feels that it is possible to tell the difference between the work of women and that of men might be inclined to believe that there is such a thing as biological determinism, and might therefore agree with Lucy Lippard's statement, made in 1976, that

the overwhelming fact remains that a woman's experience in this society – social and biological – is simply not like that of a man. If art comes from inside, and it must, then the art of men and women must be different too. And if this factor does not show up in women's work, only repression can be to blame. (Kent and Morreau 1990:22)

Such beliefs have become less common in the feminist movement during the late 1980s and early 1990s, with many writers insisting than the movement itself must encompass and acknowledge the very different experiences of women of different ethnic and class backgrounds. From the point of view of this

book, it would thus follow that we should recognise that the experiences of women in different historical cultures are likely to result in the production of vastly differing kinds of art work. It is therefore rather unexpected to find that in the case of embroidery produced across a wide variety of cultures and through the course of a number of centuries, there is evidence of a surprisingly world-wide, cross-cultural and transhistorical phenomenon: that whereas embroidery has in general been carried out by both men and women, in most cultures the work produced by men has been done on a professional basis, male embroiderers producing high status work for the market place. Women, on the other hand, have worked in both professional and amateur capacities, as the late eighteenth-century British waistcoat discussed here demonstrates.

The class structure of eighteenth-century British society affected the production of embroidery as it did almost every aspect of life, so that there was a marked difference between work produced to be used or worn by the very highest level of society and that for people of lower rank. This was cut across by a further separation between work produced professionally and the work of amateurs. Amateur embroidery was an important part of the lives of the wives and daughters of gentlemen, in that it affirmed not only their leisured social status but could also function as an emblem of chastity, as the embroideress through her work avoided the temptations which might lie in idleness. Nevertheless it was also true that for women of lower social rank this same occupation could have quite different connotations of female seductiveness. Pamela, the servant heroine of Samuel Richardson's novel, comes to regret having learnt 'to flower' (the common term for embroidery then almost entirely dominated by representations of flowers) and to believe that it would have been better for her to have learnt a skill which would have enabled her to earn her living than one which merely displayed her leisured femininity and so suggested her sexual availability to the master who eventually rapes her. Thus, if worked by a lower-class woman on an amateur basis, a waistcoat such as the one discussed here might function to affirm the social status of the male wearer whilst at the same time producing an image of its female creator as a self-interested seductress.

However, as the illustrations for many contemporary texts on the subject of embroidery confirm, women were employed in eighteenth-century Britain and France on a professional basis to embroider clothing such as male court dress, which was during the late eighteenth century as spectacularly decorated with embroidery as that of women. Both Denis Diderot's *Encyclopédie ou Dictionnaire Universel des Arts et des Sciences* (1762–65) and Charles Germain de Saint Aubin's *L'Art du Brodeur* (1770) show workshop interiors with women embroidering waistcoat fronts stretched across wooden frames, and it is known that the circumstances of production of such clothing were at this time very similar on both sides of the channel. Thus the main distinction in the production of embroidery was not between that produced by men and women, but between professional and amateur work. Amateur work was, for the most part, much less complex that that done by professionals; Saint Aubin suggests, for example, that *petit point* chair covers were produced in eighteenth-century France by nuns working on an amateur basis, since such repetitive work was considered too easy and too tedious for professionals.

By contrast, the question of who carried out the embroidery on items such as the Chinese dragon robe discussed here has received very little attention. Producers of work such as this almost always worked anonymously; the recorded instance during the Ch'ien Lung period (1736–95) of the name of the superintendent of one of the Imperial factories being woven into the selvedge of fabrics made under his supervision is exceptional. It seems likely, however, that this robe, to be worn by a government official, was designed by one of the Imperial court artists, and then embroidered and made up according to strict specifications by men working in one of the three textile centres in South China administered by the

court. Modern historians have followed the priorities of the producers and consumers of such items of clothing in paying much more attention to the symbolism carried within the embroidered decoration than to the conditions in which it was produced. In the photograph we can see five of the nine Imperial dragons chasing flaming pearls through a cloud-filled sky, below which are mountain tops breaking through a band of turbulent waves which stem from the rivers represented by the lowest band of multi-coloured lines. In addition there are numerous Buddhist emblems, such as constellations of stars, endless knots, formalised circular golden *shou* characters (meaning 'longevity'), and bats, a punning reference to the fact that the words for both 'bat' and 'happiness' have the same sound in Chinese. The presence of these should not be taken to indicate that the wearer was necessarily devoutly religious. These symbols functioned almost as talismans, intended to attract wealth and good fortune; effectively they were images of the status and wealth sought by the wearer.

Both the British waistcoat and the Chinese robe were intended to be worn underneath another garment, in one case a frock coat, and in the other a dark blue surcoat known as a *pufu*, onto which would be sewn square 'badges' embroidered with bird or animal insignia identifying the official's rank. However, the absence of such formal emblems of rank on the waistcoat did not prevent it from functioning as an indicator of the wealth and status of the wearer; the high cost of both the materials and the embroidery alone indicated the wealth of its owner, Sir J. T. Stanley, Bt. (1735–1807), whilst its design reflected his leisured lifestyle. More significant here is the possibility that the absence of symbolism in the floral decoration of the waistcoat may be related to the steadily growing association of women with flowers. As Pollock and Parker have pointed out, during the sixteenth and early seventeenth centuries, flowers could carry a number of symbolic meanings associated with their physical or medicinal properties, or with their heraldic associations. By the eighteenth century, however, the use of flowers in painting as in other forms of art had come to be associated almost exclusively with women, to the detriment of both. Flowers, like women, came to be regarded as beautiful, graceful and decorative but ultimately devoid of further significance (Parker and Pollock 1986:51–2).

ELISABETH FRINK 1930–93
Warrior Bird 1960
Watercolour 76.5 x 56.7 cm (D.1962.14)

REG BUTLER 1913–81
Figure on a Sling: no 1 1960
Pencil and black chalk
94.6 x 68.5 cm (D.1961.13)

THESE DRAWINGS were produced by artists widely celebrated at the time, although both were better known as sculptors than draughtsmen or women. Both works are figurative; Butler's drawing shows a woman bent backwards over a trapeze or swing, her breasts thrust forwards, her arms, head and hair hanging down and her face hidden in shadow. The issues of both sexuality and gender have been central to critical discussions of the subject matter and the careers of both artists. Butler caused controversy not only through his images of the female nude but also because of his extreme statements about gender and creativity; Frink was one of the few women artists to have explored both masculinity and the male figure through several decades of work, yet she was uneasy with the view put forward by feminist critics that her work was both an exploration and a criticism of masculine power, maintaining instead that her interest in the male body stemmed primarily from formal considerations.

Warrior Bird was part of a series of drawings and sculptures of birds which Frink had been producing since the early 1950s. She later said that these 'were really expressionist in feeling, with their emphasis on beak, claws and wings – ... vehicles for strong feelings of panic, tension, aggression and predatoriness' (Frink 1990:42). Frink's comments about these works, however, contain some contradictions; she

maintained that the birds 'were not ... symbolic of anything else; they certainly were not surrogates for human beings or "states of being"', but she also claimed that 'the birds ... were indeed implying more than the generalised physical body of a bird. ... the war and violence around me must have been the reasons for my interest, at the time, in violence and aggression' (Frink 1990:42).

Such contradictions within Frink's comments about her work have been compounded by conflicts between her own accounts of her motivations and those of several critics. Frink liked to present herself as a detached observer of human and animal life, suggesting that her work 'has never been concerned with symbols or connected with anything other than what you see in front of you. If any symbolism is there, it is absolutely buried in my subconscious mind.' (Frink 1990:42). Sarah Kent, however, has suggested that the main theme of Frink's work was 'that of the masculine identity as revealed though the behaviour of birds, animals and men' (Kent 1985:18).

Kent argued that, in work such as the bird series, Frink would move from an initial admiration of the power and heroism of action to a more critical stance which stripped away the 'male myths', revealing only horror and terrorism. Kent saw Frink's work during the 1970s as representing a change of mood,

showing men at peace with themselves, but also containing an exploration of female sexuality. Now Frink was 'depicting the male with astonishing warmth and sensuality. Rarely has a woman's sexual interest been expressed with such relaxed eroticism.' (Kent and Morreau 1990:102). Frink, by contrast, has resolutely avoided discussing her work in such terms; she has explained her preference for male bodies simply by saying, 'I don't find the female form the slightest bit interesting to sculpt. I can appreciate its beauty, but it hasn't got the structure.' (Lucie-Smith 1994:105).

There are several ways to approach this apparent dichotomy. Traditionally art historians, including a large percentage of museum and gallery curators, have tended to regard artists' comments about their own work as sacrosanct. Many curators of contemporary art, on acquiring a new piece for 'their' collection, will write to the artist asking for comments which will then be used on exhibition and display labels as evidence of the 'meaning' of the work. Similarly, the dominant way of writing about art, especially twentieth-century art, has been the 'life and works' format, as if the biography of an artist explained her or his work. Obituaries of Frink similarly tried to explain the different phases of her work by reference to her psychological changes: 'The six years she spent in France marked a rejection of the aggressive and brutal in favour of the more social aspects of man's nature. The impact of the Mediterranean life and culture … combined to bring growing peace of mind.' (*Daily Telegraph*, Obituary, 20.4.93). By this reckoning, the difference between Frink's own interpretation of her work and that of several critics can be accounted for in two ways: either the critics are simply wrong, or the explanation must lie in psychology; as Frink herself is quoted above as saying, 'If any symbolism is there, it is absolutely buried in my subconscious mind.'

Another possibility, however, is that the two categories, 'the artist' and 'the work' are social constructs, and therefore in no sense should one be seen as explaining the other. In this case the artist's comments about her work take their place amongst many diverse representations, of equal validity. The problem here is that such ideas remain difficult for many art gallery visitors to accept. Having been accustomed to seeing 'great' artists' work primarily as the outward expression of inner turmoil, an approach encouraged by such representations of artists' lives as *The Agony and the Ecstasy* (Irving Stone's book, made into a Hollywood film starring Charlton Heston as Michelangelo) and *Vincent* (a song by Don Maclean about Van Gogh), many visitors feel unable to interpret an object displayed in an art gallery except by reference to the life of its producer. They thus regard with some anxiety suggestions that artists should not be regarded as the sole guardians of the meaning of their work, and the tendency of many artists to claim that their work has no fixed meaning and that each viewer must take away whatever meaning(s) they choose. Many visitors do not have sufficient confidence in their ability to negotiate the specialised conditions – the gallery setting, the social circumstances – in which art is displayed to enable them to believe that their own responses have any validity at all.

Such viewers may feel comforted by recent critical response to Reg Butler's work which has, by contrast to the interpretations of Frink's work discussed above, been content to see an unproblematic continuum between the artist's own statements and his work. That is not to say that his work has not been controversial – it has caused widespread outrage – but there has not been such a disparity between his stated aims and the reception of his work as there has been with Frink. In lectures given to students at the Slade School of Art not long after the production of *Figure on a Sling*, Butler made it clear that he believed that masculine sexuality was the driving force behind the creation of art: 'The pleasures of smearing paint and handling clay are obviously comforting, and closely allied to, if not substitutes for, erotic activity' (Butler 1962:39). Furthermore, he was convinced that

'the vitality of a great many female students derives from frustrated maternity, and most of these, on finding the opportunity to settle down and produce children, will no longer experience a degree of passionate discontent sufficient to drive them constantly towards the labours of creation in other ways' (Butler 1962:11). Butler felt that the high percentage of female students attending art schools was a direct consequence of the fact that it had become 'fashionable' to ignore the 'biological differences between men and women', asking, 'Can a woman become a vital creative artist without ceasing to be a woman except for the purposes of a census?' (Butler 1962:21).

Butler's lectures were published in 1962, although it was not until considerably later that feminist publications began to draw attention to their crude sexism (Parker and Pollock 1986:6–7). Butler's work had began to draw the attention of feminists in the mid-1970s, when he produced a series of life-sized bronze female nudes, painted with decided emphasis on their pink nipples and pubic hair. These works were widely denounced when they were included in the retrospective exhibition shown at the Tate Gallery in 1983–84, which caused a further downturn in his reputation. By contrast, feminist criticism of Frink's work has, since the mid-1980s, caused a marked upturn in her reputation which had for some years appeared to be flagging.

The problem here is that the difference between the current critical reputations of Frink and Butler can easily provide ammunition for those who feel beset by political correctness and who believe that feminism is a monolithic category, representing a specific set of beliefs shared by a minority of, in their eyes unattractive, women. From this point of view, feminist critics are seen to be promoting only a narrow range of work by those artists whose political outlook agrees with their own, whilst rejecting the output of artists with differing viewpoints. This, however, is fundamentally to misrepresent feminist criticism. As Katy Deepwell has argued, 'Feminism is not a singular approach but a broad umbrella term for a diverse number of positions and strategies amongst women involved in the production, distribution and consumption of art.' Instead, feminist art criticism 'charts the shifts and changes in the arguments, issues and theories it addresses as much as it intervenes to outline positions, give voice to experience and identify the relative, complex, often contradictory, positions of women as artists, curators, critics, teacher and viewers' (Deepwell 1994:6–7).

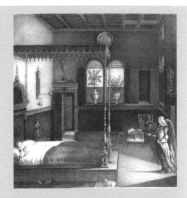

W. KATE MALLESON GOODWIN
working 1873–93
after Vittore Carpaccio
The Dream of Saint Ursula
Watercolour and bodycolour
85.5 x 83 cm (D.1908.25)

HERCULES BRABAZON
BRABAZON 1821–1906
after Giovanni Bellini
Doge Leonardo Loredan
date unknown
Pencil, watercolour and bodycolour
19 x 16.8 cm (D.1970.18)

O NE REASON for including a pair of copies in this section is to provide an opportunity to consider the idea, ubiquitous in Victorian and early twentieth-century writings on art, that certain innate qualities make women artists better copyists than men. The strength of this belief led many writers to suggest that women should limit their aspirations to this kind of work alone, since more demanding kinds of art practice required a kind of inspirational fire found only in male artists. The art historian R. H. Wilenski argued that, even when trying to produce original work, women could not help being copyists in one way or another: 'Women painters as everyone knows always imitate the work of some men.' (Wilenski 1929:93).

Despite apparently being made for similar purposes – to record the appearance of celebrated Italian Renaissance paintings – there are significant physical differences between these two watercolours which point to the quite different circumstances in which they were produced. The difference most clearly visible in the reproductions discussed here is the way in which each artist has handled the watercolour medium: whereas the individual brush marks are hidden in Goodwin's painting, in Brabazon's work they are emphatically visible, particularly in the white bodycolour strokes suggesting the highlights on the Doge's cap and cape. Not visible in the reproductions here is the quite

different scale of the two works: Goodwin's is over twenty times the size of Brabazon's watercolour. This, of course, affects the first point, since Brabazon's work is reproduced more or less the same size as the original, whereas Goodwin's is substantially smaller, so that one would expect the brush marks of the former work to be clearer. Nevertheless, the point is also true of the actual works, whilst their differing sizes are indicators of the quite different purposes for which they were produced.

Goodwin was one of a group of artists, male and female, employed by John Ruskin during the late 1850s and 1860s to produce painted copies of works of art and architecture (Sumner 1989:74). Ruskin's intentions were twofold. Primarily he wanted faithful reproductions of works of art and architecture which would preserve in detail the appearance of objects whose physical conditions were deteriorating. Ruskin also used copies for educational purposes: some were exhibited as part of his project to improve the material condition of the poor by providing better working conditions and educational facilities through the founding the Guild of Saint George and its associated museum in Sheffield; others were used to illustrate lectures given at Oxford University and elsewhere. At the time neither the newer photo-mechanical nor the traditional printing processes could provide the combination of accurate rendition of both

colour and detail which Ruskin wanted; he described traditional line engraved copies as 'done with refusal of colour and with disadvantage of means in rendering shade' (Ruskin and Wedderburn 1903–12, 20:463). Ruskin therefore valued the work of these artists very highly. Most of them were effectively employed as members of the Guild of St George, and Ruskin spent enormous amounts of time teaching and training them to work as he wanted, encouraging them to produce copies which were 'wholly unmodified by the artist's execution' (Ruskin and Wedderburn 1903–12, 10:104). However, Ruskin never allowed them to cherish any illusions that what they were doing was anything other than a lesser level of artistic activity; to William Ward, who made copies of Turner watercolours for Ruskin, he wrote, 'If I thought you could be a successful artist, I would not let you copy' (Ruskin and Wedderburn 1903–12, 36:534). Furthermore, although, since he employed both male and female artists in this work, Ruskin clearly did not believe that the ability to make faithful copies was a talent exclusive to females, nevertheless in general he had a low opinion of the capabilities of women. He wrote to Isabelle Lee Jay that 'many women are now supporting themselves by frivolous and useless art', whilst she, by copying Turner's watercolours, had 'the happiness of obtaining a livelihood in a more honourable way by aiding in true educational efforts, and placing within the reach of the general public some means of gaining better knowledge of the noblest art' (Ruskin and Wedderburn 1903–12, 12:578).

Brabazon, by contrast, was an amateur artist, a wealthy country gentleman who, on the deaths of his father and elder brother, inherited estates in England and Ireland. Leaving the management of these estates to his nephew and brother-in-law, Brabazon spent his summers sketching in Britain, and winters travelling Europe in the company of other wealthy educated men, including John Ruskin, with whom he toured France in 1880. Unlike Goodwin, therefore, Brabazon was painting entirely for his own purposes, producing over a hundred works such as the one discussed here, which he described not as copies but as 'souvenirs'. Brabazon chose this word in order to suggest that his aim was not to make a faithful copy of the appearance of another work of art; in this example he has changed the proportions of the original by omitting the parapet which appears along the lower edge of Bellini's portrait, and he has made no attempt to reproduce the detailed description of the Doge's costume. Instead he produced these works as a mixture of homage to those earlier artists he most admired and a kind of variation on a theme; indeed, Ruskin himself made a clear distinction between Brabazon's work and that of the St George's Guild artists, claiming, as he never would of his copyists, that 'Brabazon is the only man since Turner at whose feet I can sit and worship and learn about colour.' (Beetles 1989).

This further explains the notable difference in each artist's use of the watercolour medium, as well as the different sizes of their paintings. Although Goodwin's work is less than a third of the size of Carpaccio's oil painting (now in the Accademia in Venice), it is nevertheless on sufficiently large a scale to record the work in substantial detail, so that its production must have taken a considerable amount of time; certainly months and possibly over a year. Brabazon, however, valued watercolour not for its capacity to render finely painted detail but for the speed with which it could be applied; his copy is much smaller than the original (in the National Gallery, London), and would have taken him much less time to paint – indeed it has has been claimed than none of his 'souvenirs' took him more than thirty minutes to execute (Weil 1986).

This leads us back to the differing intentions of the producers of these drawings; since Goodwin may be presumed to have been paid for her work, either in the form of a salary or a payment for individual pieces, it is tempting to suggest that her time was not valued very highly if so much of it could be expended on a single copy (when Ruskin himself made a copy of the same painting ten years earlier he

worked on a much smaller scale – see Hewison 1996:103–4). However, there are other factors which should also be taken into account, in particular the changing status of the amateur painter during the nineteenth and early twentieth centuries. One interesting thing about this pair is that it reverses the expected pattern of professional male/amateur female which is still frequently encountered in areas of creativity in which women have worked on a domestic, amateur basis whilst men are celebrated as the top professionals, such as cookery. Nevertheless, in this case the reversal still does not work to Goodwin's advantage, in that, as a professional artist, she is now seen as someone who was literally 'in the pay' of someone else, working at Ruskin's behest and following his instructions. During the late nineteenth century, however, critical reaction to Brabazon's work showed an intriguing tendency to graft an older ideal of the disinterested amateur onto an emergent modernist ideal, so that Brabazon was presented as an artist of genius whose private income allowed him to work unshackled by the demands of patrons or purchasers; thus when Brabazon was finally persuaded to exhibit some of his work in 1892 he was hailed by critics as the 'best watercolour painter we have had since Turner' and 'a curious anticipation of the artistic ideals of to-day' (Beetles 1989); in other words, he was, at the turn of the century, seen as the longed-for *English* 'missing link' between the achievements of Turner and the Impressionists. His reputation did not, however, continue at this high peak; ironically enough, as the emergent modernist ideal contributed to the inflation of Brabazon's reputation, so it later contributed to its decline. The term 'amateur' came increasingly to be used in various fields as a pejorative term. In the field of painting it was equated with the work of countless nineteenth-century female watercolourists whose achievements and subject matters were denigrated in favour of the masculine media and concerns of the modernist movement; Brabazon's reputation has sunk alongside theirs.

CECILE ELSTEIN b.1938
One with Another 1988
Screenprint
Sheet size 120 x 91.5 cm (P.22836)

HOWARD HODGKIN b.1932
David's Pool at Night 1979/85
Soft ground etching with hand-colouring
Sheet size 63.6 x 79 cm (P.22464)

THE COMPLEX ways in which issues of gender interrelate with modern notions of artistic creativity are especially well illustrated in the context of contemporary printmaking. Many of the problems involved centre around the particular phrase which is often used to describe works such as the two prints discussed here: 'original prints'. The need to qualify the noun 'print' with the adjective 'original' became increasingly strongly felt as the modernist movement began to suggest that the fundamental character defining a work of art was its originality. As this notion of 'originality' became further confused with a notion of uniqueness, so it became difficult to reconcile the process of producing prints, by definition produced in multiples, with notions of artistic creativity. The marketing of certain types of prints under the label 'original prints' was intended to suggest that these were prints designed and produced by artists, as opposed to other kinds of print which merely reproduced pre-existing images. However, the term itself carries its own internal contradictions: if a work is designed from the outset as a print, each impression from the edition will be equally 'original', as there is no pre-existing image being copied which might be seen as the 'original' of which the prints are all 'reproductions'; in this instance therefore 'original' and 'unique' are by no means co-terminus. Furthermore, the term 'original print' is often used as though it were interchangeable with the term 'limited edition print', so that reproductions of paintings by artists such as Lowry are described as 'original prints', even though the precise meaning of the word 'original' is in this context even harder to define.

This complex web of definitions was made even more tangled by the increasing realisation that artists' prints were not always the result of an individual artist conceiving a design, carving it into a wooden block or etching it onto a metal plate, and then printing it. As the production of artists' prints increasingly involved ever more complex technologies, so the myth of the artist as the sole producer of 'original prints' became ever more problematic. In this way, the earlier distinction between 'reproductive' and 'original prints', which distinguished between the former works which were designed by one hand but executed by another, and the latter which were both designed and executed by an artist, became impossible to maintain. As the process of screenprinting developed in this country as a medium for artists, for example, the technology involved became increasingly specialised, involving the use of processes derived from photography to produce screens for printing, so that many artists, not wishing to learn the processes themselves, would work with a specialist printer; the resulting 'original print' was made not by the hand of a single artist but as the result of a complex collaborative process.

Many contemporary print historians, notably Pat Gilmour, have been at pains to stress that the whole notion of 'original prints' is a blind alley, and that instead of continuing to argue over the correct definition of the term, artists, critics and the print-buying and viewing public should open their minds to the wide variety of different ways in which printed images have been made and circulated in different cultures at different historical periods. Eminently sensible though this advice is, the term doggedly refuses to die, partly because it is so integral to the way in which prints continue to be marketed in the Western world today. This is not to say that artists or publishers deliberately suppress information about the ways in which artists' prints are produced. Most publishers are quite frank about exactly how the prints they are issuing were made, and it is clear that collaboration is now common not only in more technically complex process such as lithography, where artists have traditionally relied on the expertise of specialised printers, but also in media for which artists have traditionally preferred their own hand-crafted printing, such as woodcut. Since the two works under discussion are not only both prints, but were also both produced by men and women working in collaboration, these issues are central to any discussion of the way in which gender issues have affected their production, marketing and reception.

The obvious difference between the two collaborative projects is that one involved an internationally famous male artist, Howard Hodgkin, being assisted by an unknown female who, in different contexts, might be referred to either as an 'artist' or as Hodgkin's 'assistant', whilst the other involves two lesser known artists working together in a more equal partnership. In an interview given not long after his print was published, Howard Hodgkin described, in some detail, the way in which his latest series of prints, including *David's Pool at Night*, had been produced. Each involved collaboration between Hodgkin and a group of assistants led by Jack Shirreff, who helped not only with the production and printing of the plates, but also with the hand-colouring of the final images. Hodgkin has for some years preferred the final layer(s) of colour on his prints to be applied by hand rather than being printed; furthermore, he has preferred this colouring as far as possible to be carried out by other people rather than himself. He claims to regard the application of colour by hand as being no different to the printing of a colour from a plate: he regards both as being the responsibility of the printer. He therefore saw the hands of Jack Shirreff, and, in the present case, Cinda Sparling, who applied the hand-colouring on most of the prints in the edition of *David's Pool at Night*, as being just 'another instrument in the process' (Simmons 1991:7).

However, the issue of hand-colouring is not as clear cut as this might imply; many publishers, dealers and purchasers of Hodgkin's prints not only see the hand-coloured areas as being more important that the printed ones, but also make a distinction between hand-colouring applied by the artist and that done by the assistant; a trial proof of *David's Pool at Night* inscribed 'painted by HH' was exhibited by a dealer in 1991 with a price tag of £10,000, whereas an impression from the main edition, hand-coloured by Cinda Sparling, was priced at £8,500. There are many aspects to the complex ideologies underpinning this distinction, which was clearly not based on readily detectable visible differences between the two prints. The assumption that Hodgkin is a better painter than Sparling is here bolstered by the continuing widespread suspicion of versions and any hints of 'mechanical' repetition in art. In this case Hodgkin's hand-painted proof is clearly assumed to be the 'original', of which those prints coloured by Sparling are merely repetitions. This is related to another widespread assumption that the first version of any work of art must be closest to an imagined source of inspiration, so that, when different versions exist of the same image by the same artist, a higher financial value is placed on the one which can be proved to have been produced first, in spite of the entirely reasonable possibility that in repeating a composition the artist may well find ways to improve it.

A further problem is caused by the fact that the hand-colouring in most of Hodgkin's prints plays a structural rather than a merely decorative role; in other words, unlike the hand-coloured prints which were produced in eighteenth- and nineteenth-century Britain, which could be purchased either plain or (usually at double the price) coloured, Hodgkin's prints are incomplete without the hand-colouring, and so are not sold without it. The reason this causes difficulties is because Hodgkin's work places such emphasis on the gesture of the artist. To suggest that these gestures are neither unique to the male artist/genius nor to a particular moment, but can instead be repeated any number of times by a female assistant, is quite a challenge to many currently widespread assumptions about art in general and about abstract art in particular. These prints therefore present a significant challenge to the idea that artists work intuitively, and are unable to express what they are trying to achieve in any other way; this is difficult to maintain in the face of works of art such as this, in which the artist's gestural mark is repeatedly made by another person.

By contrast, the collaboration involved in the production of Cecile Elstein's print was of a quite different nature, although on the surface it would appear to have involved a female artist working with a male assistant. *One with Another* was produced at a professional screenprinting workshop in Cambridge, where Elstein worked in collaboration with a man named Kip Gresham who, although frequently referred to as a 'master printer', in fact works as an artist himself, as well as collaborating with other artists. Unlike the decidedly minor role assigned to Sparling in Hodgkin's print, Gresham's contribution here was not only to advise on the choice of inks and papers, but also to supervise, and at times carry out, the preparation of the screens to be used for printing; the actual printing of the edition was done by Gresham and an assistant, with Elstein working alongside them at every stage. Elstein came to the workshop having worked for several weeks making preparatory drawings, testing colours and devising a strategy for the image she wanted to make, but the final print contains an inextricable mixture of her own ideas and Gresham's technical expertise, as the image continually developed and changed as the two people worked on its production.

4 The home and the family

THREE OF the four pairs in this chapter consist of objects produced in Victorian England. Of central importance to these works is the notion of the nineteenth-century middle-class ideology of 'separate spheres'. It has been argued that the Victorian social order was one which allotted separate and oppositional roles to men and women, the former occupying the world of public affairs and business, and the latter inhabiting a private domestic world centring on the family home. The question this raises is whether we should expect the more intimate knowledge of domestic life thus acquired to be evident in the design and artwork produced by women, particularly if, as is the case here, the objects in question were specifically intended for use in the very areas of the home which would appear to have been the domain of women?

Instead of answering these questions directly, we should perhaps consider whether the very fact that we are looking at the involvement of women in the professional worlds of art and design should alert us to the dangers of thinking that the 'separate spheres' model sums up the way in which sexual difference was organised and produced in Victorian England. Feminist art historians such as Griselda Pollock and Deborah Cherry have drawn attention to the complexity of the ways in which notions of masculinity and

there remain gentle scenes of home interest, and domestic care ... with which the woman artist is eminently entitled to deal.

Anonymous (*The Englishwoman's Review*, 18 April 1857)

femininity were constructed, a complexity which we should be careful not to reduce to any simple notions of binary opposition (Pollock 1988; Cherry 1993). This is supported by the fact that in this chapter as in almost every other in this book, further investigation suggests that the binary opposition represented by the pairs of objects illustrated does not adequately describe the circumstances in which the objects were either produced or consumed. Instead of thinking of the experiences of women and men in Victorian England as being constrained by an ideology which allotted them fixed and opposing roles, it is more useful to think of this as being shaped within a shifting interplay of ideas concerning race and class as well as gender, played out within psychic as well as social realms.

Nineteenth-century images of domesticity took their place not only amongst ideas such as these, but also in debates about painting and about the suitability of the forms of history painting to deal with issues of modern life. Many participants in this debate recommended domestic subjects as especially suited to modern Britain. They did this, however, not on the basis that domestic subjects were exclusively the concern of women; instead, they were seen as being of universal importance to humanity, and as helping to promote a sense of national unity which could transcend social difference;

England, happy in her homes, and … peaceful in her snug fireside, is equally fortunate in a school of Art sacred to the hallowed relations of domestic life. From the prince to the peasant, from the palace to the cottage, the range is wide; yet the same sentiments … the outpourings of our universal humanity, have found earnest and literal expression through domestic pictures. (*Art Journal* 1863, quoted in Cherry 1993:122)

Nevertheless, even if the ideals of domesticity were not considered exclusive to women, we may still ask if women represented such ideals differently, or if women viewers responded to paintings of domestic life differently? This is one of the questions which readers might consider when studying the pairs of objects reproduced for this chapter. A further point which should be borne in mind is that women artists who painted scenes of domestic comfort challenged, by the nature of their occupation, the very ideals contained in their imagery. Many Victorian women artists were told in no uncertain terms that domestic responsibilities and painting were incompatible, and that proper attention to the former would leave no time for the latter (see Nead 1988). The first pair of paintings discussed in this chapter provides an opportunity to investigate further these apparently conflicting nineteenth-century roles of artist and mother. Others deal with the production of consumer goods designed to decorate what might appear to be the most exclusively female domain of the house – the nursery – as well as looking at representations of the relationship between a mother and her child. The penultimate pair are images whose appeal to the emotions is centred around the vulnerableness of children.

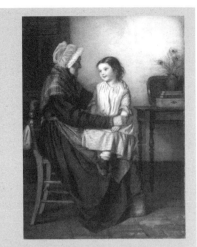

EMILY FARMER 1826–1905
Old Woman with a Girl on her Knee
date unknown
Watercolour and bodycolour
37.5 x 27.4 cm (D.1919.1)

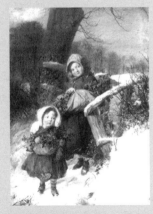

FREDERICK J. SHIELDS 1833–1911
The Holly Gatherers 1858
Watercolour and bodycolour
48 x 33.6 cm (D.1930.60)

THIS IS ONE of a small number of pairs of works in this book which at first glance might appear to have been produced by the same person. Both highly finished and meticulously detailed, these two Victorian watercolours present sentimentalised views of childhood at variance with other forms of historical record which show Victorian children as exploited workers or suffering the effects of repressive educational theories. Shields' *The Holly Gatherers* is one example of a type of subject matter especially popular amongst both male and female Victorian artists, showing poor children in landscape settings, engaged in seasonal occupations such as gathering walnuts or picking spring flowers, activities which gently prepare them for their future, adult lives of rural labour. Like the children in most of these pictures, Shields' two young girls have smiling faces and healthily reddened cheeks, and appear to be taking innocent pleasure in the countryside which surrounds them. In spite of the slight frisson of danger suggested by fact that the elder of the two children appears to be just passing through a gap in the wooden fencing – are these children trespassing? or have they merely climbed over a stile? – the scene's continuing power to offer reassurance and unthreatening charm is confirmed by its long-standing popularity on Whitworth Art Gallery Christmas cards. For its original Victorian audience of urban middle-class adults it would have reinforced the consoling myth of the countryside as a place of spiritual harmony in which rural labour is pleasant, health-giving and 'natural'.

The figures in the interior shown in Emily Farmer's work are little better off than the holly gatherers; the cold brick floor and bare plaster walls suggest a life without luxuries, although, like Shields' girls, their bodies and clothing suggest that their hardship brings them no great suffering. Once again this scene is an example of a popular Victorian genre: the domestic interior with a happy family group. Countless nineteenth-century images, written and painted by both women and men, stressed the role of women in maintaining a comfortable home and nurturing the next generation. A writer in *The Englishwoman's Review* of 18 April 1857, described a feeling widespread in Victorian England that such subjects were particularly suited to women artists:

It may be that in the more heroic and epic works of art the hand of man is best fitted to excel; nevertheless there remain gentle scenes of home interest, and domestic care, delineations of refined feeling and subtle touches of tender emotion, with which the woman artist is eminently entitled to deal.

At first sight it would seem that Farmer in no way tries to subvert or undercut the repressive effects of a definition of femininity centred exclusively on the home. There is, however, on further inspection, a paradox at the heart of her work which gives it an intriguing quality noticeably absent from Shields' highly

conventionalised work. The paradox centres less on what is represented in the picture than on what is absent from it. We are accustomed today, as were Farmer's original audiences, to seeing images of a mother with her child in domestic or 'genre' scenes which acquire an aura of blessedness from the faint echo they contain of the relationship of the Christ child with his mother. In this case, however, the conventional expectations are thwarted by the fact that the woman in whose lap the child is seated appears to be too old to be her mother, hence the fact that the painting, whose original title is unknown, is sometimes known as *The Grandmother*; indeed, an invoice dated 1913, six years before the painting was bequeathed to the Whitworth, gives the title as *Grandmother's Pet*. This then introduces a further question: where is the child's mother?

There are numerous possible answers to this question, all of which are equally unprovable and all in many ways equally beside the point, since most works of art ask to be read only in terms of the information which they give us. Nevertheless, it is a testimony to the power of the realist style in which both Farmer and Shields painted that their works raise such questions; it is also true that these kinds of narrative readings were commonly discussed by contemporary critics. A narrative is implied by the exchange of glances between the two figures in Farmer's work which encourages us, as viewers, to construct a story, a history of events linking the two females from different generations. We might wonder, for example, whether the older woman has taken over the task of bringing up the little girl after the death of the child's mother, an occurrence which was especially common at a time when childbirth remained a mortally dangerous event.

It is at this stage, however, that our knowledge, or lack of knowledge, about the gender of the artist who painted this picture becomes important. Once made aware that this work was by a woman, a group of women attending a workshop prior to the opening of the *Women and Men* exhibition were tempted to construct a narrative in which the artist and the absent mother were one and the same person, thus conflating the personal, the domestic and the professional in a way which drew strong feelings of sympathy from those in the group who felt the pressures of trying to combine a career with raising children in Britain in the 1990s. On the face of it, it seemed quite possible that the artist may have used her family – her own mother and her daughter – as models, and her own home as the domestic setting. This is certainly known to have been the case for many Victorian women artists, the restrictions on whose movements outside the home meant that it was easier to work from subjects inside, to make their home their studio and to paint from family and friends rather than paid models. Again, some of the women at the workshop felt an especially poignant response to the work as they described the way in which it recalled to them the powerfully ambivalent feelings they experienced in leaving their children to the care of another woman whilst they themselves went off to work; they imagined that the artist here must have experienced something of the same feelings as she carried out her professional work as a painter, whilst her work as a mother was carried out by the child's grandmother.

These responses to the painting are in no way devalued by the fact that what little historical evidence we have about Emily Farmer suggests that she was unmarried and childless. The daughter of John Biker Farmer, who worked for the East India Company, she, like so many other Victorian women artists, was taught to paint at home by a male relative, her brother. As Deborah Cherry has pointed out, Elizabeth Ellet, in the first book about women artists to be published in England, *Women Artists in All Ages and Countries*, published in 1859, described the family as one of the most important institutions shaping women's desires and ambitions; Ellet recognised that

In most instances women have been led to the cultivation of art through the choice of parents or brothers. While nothing has been more common than to see young men embrace the profession [of art] against the wishes of their families, ... the example of a woman thus deciding for herself is extremely rare. (Cherry 1993:19)

As 'Miss Emily Farmer' she exhibited three works at the Royal Academy between 1847 and 1850, becoming a member of the New Water Colour Society in 1854, where she continued to exhibit until 1904, a year before her death. However, in spite of the fact that the actual career of this artist contradicts the biographical interpretation of the painting described above, the work nevertheless still functions to articulate the tensions and conflicts posed for and by the professional woman artist in Victorian Britain. As Cherry has shown, the experiences of women artists could vary widely, though a significant number remained, like Farmer, as spinsters; many relished the freedom which the absence of the responsibilities of a husband and children gave them to pursue their careers, and to make their own choices in life (Cherry 1993:45). The paradox at the heart of this watercolour nevertheless remains that Farmer, as a professional woman artist, stood outside the ideal of bourgeois femininity through which women were defined in relation to the home and the family, an ideal which such domestic scenes of family life and children as she painted were calculated to reinforce.

Works such as Farmer's demonstrate that the ideology of domesticity was not simply imposed on women; women artists, like numerous other groups of women, were actively involved in producing varying definitions of domesticity, some of which questioned whilst others reinforced prevailing consensual definitions. Nevertheless, as this pair of watercolours shows, there was a clear difference between the relationship of a male artist such as Shields to his paintings of domestic or family subjects and that of a female artist such as Farmer. For an artist such as Shields to use his female relatives or dependents as models in his paintings would simply confirm the power relations which existed in his domestic life, as his professional activities as a painter maintained and supported his wife, children and domestic servants. For a female artist such as Farmer, however, the picturing of such scenes involved the construction of a kind of domesticity which was not reflected in their own lives, so that, in choosing to paint the kinds of subject matter that were deemed especially appropriate for their own gender, they were themselves grappling with contesting versions of femininity.

KATE GREENAWAY 1846–1901
and GEORGE F. JACKSON
The Months 1893
Colour machine-printed wallpaper
manufactured by David Walker & Co.
Sheet size 59.7 x 56.5 cm
Repeat size 45.6 cm (18 ins) (W.193.1967)

WALTER CRANE 1845–1915
The House that Jack Built 1886
Colour machine-printed wallpaper
manufactured by Jeffrey & Co.
Sheet size 360 x 53.5 cm. (W.1991.3)

THE APPARENT similarities between these two Victorian machine-printed wallpapers, both produced to decorate children's nurseries, mask more fundamental differences in the ways in which they were produced. These differences in turn raise questions about the involvement of women in both the design and consumption of goods manufactured for the decoration of domestic houses in late Victorian England.

To begin with, it is doubtful whether Kate Greenaway can in any meaningful sense be described as the 'designer' of the wallpaper on the right. Many readers will have correctly identified the 'woman's work' in this case, simply because Greenaway's drawing style and subject matter is now so widely known. However, although the figures of young women and children engaged in seasonal occupations were drawn by Greenaway (for an almanac published by Routledge in 1893), they were incorporated into a repeating design suitable for a wallpaper by George Jackson under instructions from wallpaper manufacturer David Walker. Walker had bought Greenaway's drawings along with special permission to reproduce them. Greenaway, in fact, produced no designs specifically intended for wallpapers; here she was not so much the designer of the product as a means of selling it. The use of her name, printed in large capital letters along the edge of each width of paper, visible at the point of

sale, although cut off before the paper was hung, was vital to the financial success of the product. By the end of the nineteenth century Greenaway was so well known as an illustrator of children's books that the association of her name and the easily recognisable style and subject matter of her work helped this to become one of the most popular nursery wallpapers of its time; it was, in fact, still being produced well into the twentieth century.

It may be tempting to view this kind of production method with some disdain, particularly when, a century later, we are familiar with the kinds of marketing methods it has led to, from Beatles wallpapers of the 1960s, to the use in the 1990s of characters from Disney films to promote a wide range of goods targeted at children, from interior decorations to toys, clothing and food. However, we would be wrong to conclude either that Greenaway was not able to prevent her work from being manipulated by powerful male manufacturers, or that she was somehow less respectable than Walter Crane as an artist or designer because she allowed her work to be used in the production of goods in which commercial considerations appear to have predominated over aesthetic ones. The processes and negotiations involved in the production of goods for domestic consumption in late nineteenth-century Britain were complex, and the relationships between manufacturers,

designers, industrial workers, sales staff and consumers could vary enormously, contradicting any simplistic notions either of the overriding genius of the creative designer, or of a simple polarity between powerful males and powerless or oppressed females.

The 1970s and 1980s in Britain saw a marked increase in discursive activity focused around the concept of the designer. Many design historians (and this in itself was a newly-labelled activity) were anxious to ensure that designers and the study of their work were regarded with as much respect as artists and the academic discipline of art history. Their efforts in this direction, however, frequently involved the promotion of individual designers as celebrities, focusing on accounts of biographical and stylistic development in spite of the fact that exclusive use of such approaches was already being seen as flawed by increasing numbers of art historians. Nevertheless, an overconcentration on the character and function of individual artists and designers continues to be a prominent feature of many art gallery exhibitions and displays, so that it remains necessary to emphasise the varying complexities of late nineteenth-century production processes in which designers were rarely either the sole, or even the most important figure.

Overconcentration on the role of designer can mean that relatively little attention is paid to manufacturers such as David Walker who might control every aspect of the production of a wallpaper, from deciding on the nature of the product, to the dividing up and commissioning of the various stages of its production, and the development of new technical processes, as well as marketing and sales. In the two examples shown here, one of the most crucial of these decisions was the method of printing; this would influence the final cost of the product and the market at which it might be aimed. What are insistently referred to as Walter Crane's wallpapers were, if intended for rooms occupied by adults, usually hand-printed from wooden blocks; his designs for nursery wallpapers, however, were all machine-printed. This we must assume was a decision made by the manufacturer rather than the designer, since Crane is known to have disliked the effects of machine-printing; instead, Metford Warner at Jeffrey & Co. presumably thought it essential to produce cheaper papers for the decoration of children's nurseries, on the assumption that adults would be unwilling to spend as much on the decoration of these rooms as on the major rooms of the house. Papers such as *The House that Jack Built* would retail at around 2s 6d (12½p) per roll, as opposed to between 6s 6d and 21s (32½p to £1.05) per roll for hand-printed papers.

The choice of designer, then, was often a less significant consideration than the choice of printing and marketing processes; indeed, Warner was exceptional amongst wallpaper manufacturers when, in the late 1860s, he began employing architects and artists to design his products. Most manufacturers continued the older practice by which the men employed to cut the wooden printing blocks also provided the design; they were described as 'pattern-drawers' rather than designers (Smith and Hyde 1989:59); during most of the nineteenth century the anonymous designer was the rule rather than the exception. Crane was not only one of the earliest designers of wallpapers to be marketed as the work of 'an artist'; in the field of book publishing too, he was one of the first of Routledge's designers to have his name credited on the front covers of books. Even so, we should still be wary of overemphasising the sole responsibility of Crane for the final appearance of such products; Crane was in fact content to allow the block cutter freely to interpret his sketched wallpaper designs in the process of transferring them to the wooden blocks, and was happy to allow Metford Warner to resolve any remaining problems, including deciding on the colours to be employed.

Alongside this awareness of changing attitudes towards the role of design, we must also consider the question of sexual difference as it intersects with the production and consumption of wallpapers. Did wallpaper manufacturers produce nursery wallpapers

designed specifically to appeal to women? Are the two works illustrated over leaf examples of their estimations of the character of 'female taste'? The nursery may have been regarded as the province of women and children throughout the nineteenth century, but whereas earlier in the period the care of children was widely left to servants – wet-nurses, maids and governesses – as the century developed, it became fashionable for middle-class ladies to concern themselves more closely with their children's care. However, neither female servants nor their mistresses were likely to have complete control of the household budget, so any appeal to their taste on the part of manufacturers would have to be directed through the pockets of their masters or husbands. Nevertheless, the growing involvement of middle-class women with child care was accompanied by a developing association of such women with interior decoration, the tasteful arrangement of colours and furnishings being seen as a natural extension of their feminine natures. Wallpaper manufacturers, whether or not they considered marketing their products specifically towards women, were literally creating the environment in which women would be viewed, the nursery and its decoration thus appearing as natural echoes of innate qualities in women.

The development of specialised products for the nursery was, however, also part of the process by which childhood itself was constructed as a state of innocence separate from adulthood; the very production of wallpapers such as those under discussion implied that children could be defined by their possession of needs and tastes which differed from those of adults. It also, however, imbued the wallpapers themselves with a significant function. Crane argued that good design should pervade all aspects of human life, and that in doing so it could operate as a positive force for moral and spiritual improvement. In the case of children this was especially important, as the formation of their characters could be influenced markedly by the design of the surroundings in which they grew up. The significance of nursery wallpapers thus could not be underestimated, and writers sympathetic to Crane's ideas felt that wallpaper such as *The House that Jack Built* should be used by adults in the education of their children: 'Mr Crane tells the tales of fairy kind and nursery rhyme. With the aid of a little intelligent and sympathetic talk nursery walls covered with these designs might be made to live in the lives of children.' (*The British Architect* 23 May 1884). However, if Crane's beliefs lead us to regard *The House that Jack Built* as an example of a conscious effort to use imagery and symbolism as a positive influence on the lives of its consumers, we should not at the same time dismiss work such as *The Months* as lacking the controlling intention of a single designer and therefore also lacking such influence; through the more subtle processes described above, wallpaper such as this could have an equally significant effect on the lives of those who lived within the walls defined by it.

ANONYMOUS FEMALE
after an unknown artist
*Charles I Taking Leave of
his Children* c.1850
Embroidered picture,
Berlin wool work on canvas
Including frame 113 x 96 cm (T.1989.1)

THOMAS OLDHAM BARLOW
1824–89
after John Everett Millais
Awake and *Asleep* 1868 and 1869
Mixed method mezzotint prints
60.3 x 46.3 cm (P.3877 and P.3923)

THESE OBJECTS were all produced in the mid-nineteenth century as imitations of images originally conceived as oil paintings. This accounts for their superficial similarities, in that both deal with subject matter which focuses on feelings aroused by children, in a style derived from academic history paintings. Despite one being set in the mid-seventeenth century and the other being a contemporary Victorian scene, the choice of subject matter and its treatment in each image is dominated by very similar concerns. Both feature a comforting domestic interior with furnishings described in elaborate detail, and both employ individual symbolic objects, such as the hour-glass and the empty chair, to emphasise the emotional response being elicited from the viewer. In the case of the embroidered picture this response is one of sympathy for the plight of the king in his role not as a head of state but as a father, and concern for his approaching death which is heightened by the innocent lack of comprehension of the youngest child (the Prince of Wales and future Charles II), but calmed by the spiritual comfort proffered by the Bishop of London. In the case of the print the emotion called forth is also one of sympathy, this time for the childish fears of a young girl who cannot sleep without the reassuring presence of an adult.

Despite being executed in very different media – one in wools stitched onto a canvas backing, the other in lines and dots printed in ink onto paper – they also share further similarities in that both embroidery and printmaking occupied lowly places in terms of the established hierarchy of art practices in mid-Victorian Britain. It is at this stage, however, that the similarities become less significant than the differences between the objects. If we consider the specific conditions of production of both of these works it becomes clear that one difference stems from the complex relationship of both objects to commercial activity in Victorian Britain. One reason for the prints being disparaged by the *haute monde* of the Victorian art world was their obvious commercial function. The process of engraving plates from which to print hundreds of identical images for sale made the commercial nature of the exercise impossible to ignore, whereas the fact that paintings were also usually produced for sale could more easily be submerged beneath a nationalist rhetoric which celebrated the prestigious productions of the British School. The frankly commercial concerns affecting all stages of the production of Barlow's two prints – the choice of media, the choice of paper, the choice of paintings to be reproduced, indeed the very fact that the images were marketed as a pair – clearly occasioned a loss of prestige. However, the fact that the embroidery was produced in a way which placed enormous emphasis on the fact of its *not* being carried out on a commercial basis did not in itself guarantee a higher status for the work. The commercial

world, despite having been disparaged in the late eighteenth century by artists wishing to be seen to share the aristocratic concerns of their wealthiest potential patrons, was, by the nineteenth century, the natural habitat of the ruling classes, but still only of their *male* members. Some vestiges of the opprobrium attached to earned income and the importance of the status attached in eighteenth-century Britain to a conspicuously leisured lifestyle for men was transferred during the nineteenth century to women; the respectability of wealthy middle-class male industrialists was confirmed and displayed by the leisure of their wives, who, although in charge of the domestic sphere, were nevertheless freed from the necessity of doing any actual domestic work by their husband's ability to pay for large numbers of domestic servants.

However, the course of the nineteenth century witnessed subtle changes to this ideal as it gradually became more applicable to the wives and unmarried daughters of the British middle-class male industrialists. It was important that these women should display leisure and not idleness; their work contributed towards the construction of a haven domestic comfort whilst they cultivated personal qualities of self-abnegation which, alongside their own rigid exclusion from the commercial world, provided spiritual succour for the male members of their family returning home from the amoral world of

business. One way of emphasising these important distinctions was for women to be seen by visitors, or when visiting others, doing not the basic kind of needlework such as making household linen, which could be left to servants, but the kind of decorative work which was clearly not a necessity, but which could nevertheless be seen as adding comfort and decoration to their homes. For most of the Victorian era the most popular form of such embroidery was Berlin woolwork, so-called because it utilised a particularly soft wool from merino sheep which was dyed in Berlin and then exported to Britain. This wool was worked on a canvas backing usually by means of repeating the same stitch in different colours, according to the instructions given on commercially produced patterns. These consisted of decorative schemes or pictures which had been transcribed onto squared charts, and hand-coloured so that each square represented one stitch. Such embroidery could be used to decorate a wide variety of objects, such as cuffs, mittens, slippers, stool covers, bell-pulls; since it was regarded as vanity for women to be seen making objects for their own personal adornment, most of their work decorated male items of clothing and the home, rather than their own wardrobe.

Certain characteristics of Berlin woolwork made it an especially effective emblem for middle-class women, confirming both their husband's financial status and their own moral

and sexual virtue. To start with it was immensely time-consuming; this, however, was an important part of the function of such needlework, so that labour-saving devices, such as the using of larger mesh canvas, or easier ways of attaching individual beads to decorate the work, were frowned upon. Likewise, the softness of the wools meant that they could only be worked by women with very smooth hands; rough skin would catch on and possibly break the wool, so that the work itself both imposed and symbolised the restraints placed on the kind of activities which it was considered seemly for middle-class women to undertake, and the fineness and detail of the work itself also began to seem a natural reflection of qualities of delicacy associated with the female gender.

One further characteristic shared by both the works discussed here was their immense popularity. Embroidered pictures were worked by women in their thousands, and prints such as Barlow's were likewise published in editions running to thousands. This meant not only that they were criticised and denigrated by a small elite of the art world during the High Victorian era, but also that their widespread popularity thinned out towards the end of the nineteenth century, with changing attitudes towards decoration and concepts of originality. Prints such as Barlow's have for most of this century been widely regarded as inferior to the kind of print promoted by James McNeill

Whistler's followers, designed and produced by the same hand, with an emphasis on freedom of execution rather than the painstaking building up of imitative textures. Likewise, Berlin woolwork, which had always been criticised in some quarters, was by the beginning of this century thoroughly vilified:

Think of the many years which English women have spent over wickedly hideous Berlin wool pictures, working their bad drawing and vilely crude colours into those awful canvases, and imagining that they are earning undying fame. During the middle and succeeding twenty years of the nineteenth century, the notable housewife of every class amused herself at the expense of her mind, by working cross-stitch pictures with crudely coloured wools which were supposed to represent the actual colours of Nature. (Lowes 1908:35)

It is thus only in the last decade that museum curators have begun to reassess both types of work; indeed, the Berlin woolwork picture was only accessioned at the Whitworth in 1989, and the prints by Barlow were likewise exhibited for the first time since the Victorian era at about the same time. This reassessment comes not only from a revaluing of the skill involved in translating a work from one medium to another, and a renewed admiration for detailed decorative work which the era of modernism so thoroughly denigrated; it also comes from the fact that the writing of new art histories, including feminist art history, has belatedly begun to encourage curators to display and write about objects which have never been considered by academics and critics (as opposed to a wider population, with whom their popularity has often endured) as the finest works of art, but which can now be seen to have a significance which is historical rather than merely art historical.

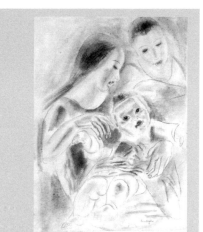

FRANCES HODGKINS 1869–1947
Adoration 1926
Pencil and watercolour
52.9 x 37.8 cm (D.1937.38)

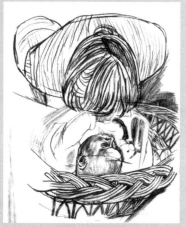

JOHN BRATBY 1928–92
Jean Bending Over David 1956
Pencil
38.5 x 29.3 cm (D.1957.1)

THE MAJORITY of those visitors to the *Women and Men* exhibition with whom I discussed this pair said that, in order to decide which had been produced by a woman, they looked for evidence of the experience of motherhood. Many of them, quite correctly, deduced that the artist who had produced *Adoration* had no personal experience of childbirth and child-rearing. Many also felt that *Jean Bending Over David* somehow suggested an intimacy between mother and child that could not merely be the result of detached observation, but must stem from the personal involvement of the artist with the subjects depicted. They thus deduced that the artist was either a woman drawing herself with her own child, or a man drawing his own child with its mother. Once told the titles of the works few visitors had any further difficulty. Both titles appear to be those given by the artists, and both can substantially affect a viewer's interpretation of the works: the familiarity of the first names in *Jean Bending over David* suggests that Bratby's drawing shows his wife and their baby son; *Adoration*, however, suggests not a personal relationship but a religious or spiritual one.

Most viewers commented on the style as well as the subject matter of the drawings. The striking width and blackness of the 6B pencil lines in Bratby's drawing suggested to some a decisiveness which they associated with masculinity, whilst the softening of the lines in the other drawing with pale watercolours suggested a feminine hand. Few visitors, male or female, felt drawn to Hodgkins' work; many found the style contrived or peculiar. When it was first exhibited in 1927, a newspaper critic described it as 'experimental', and felt that the artist was too influenced by what were then current (presumably modernist) ideas about art (McCormick 1981:103). It may be that the discomfort suggested by these responses has as much to do with the subject as with the style of the drawing; viewers at the Whitworth were particularly puzzled by the two adult figures. Those who saw in the work an echo of paintings of the Holy Family expected to see echoes of Mary and Joseph, and were disturbed by the fact that both figures accompanying the baby appeared to be women; even those who saw no echoes of religious art commented on this fact.

By contrast, John Bratby's drawing caused less disturbance to most viewers' expectations. Many were attracted by the way in which emotional ties were evoked by the sensation of physical closeness, most obviously between the mother and child, but also between the artist and the mother and child suggested by the extreme closeness of the viewpoint. Much later in life, Bratby claimed that during this period, not long after he had left art school, he painted 'just human beings. It did not matter who they

were … I sometimes painted my wife Jean Cooke as a particular person, not with affection. She was someone to paint. There, available, and did not cost modelling fees.' (Gibson 1991:7). This image has nevertheless been seen by many viewers as a reassuring reflection of the closeness of the bonds between members of a conventional nuclear family. Bratby may have believed his emotional relationship with those he was drawing was not significant, but his own identity as a heterosexual male artist nonetheless remains a factor affecting the responses of viewers to his work.

Lesbian artists are much less frequently acknowledged in art galleries and books about art; many curators and authors feel that an artist's sexuality is irrelevant to their art. However, the construction of a monolithic category 'lesbian', defined exclusively in terms of sexual activity, does not usefully reflect the variety of relationships pursued by women who have had a range of different levels of commitment to, and dependence upon, other members of their own sex. As an unmarried woman with no private income, Frances Hodgkins may have found working as a painter offered both independence and respectability. Hodgkins is known to have formed two successive, long-lasting relationships with women who were also painters, although she clearly felt the tension between the life she had chosen and more conventional expectations of women. In a letter written in 1901 she asked a friend

what better work can you do than bring up four beautiful children? My work is nothing compared to it – we poor spinsters must embrace something, if it is only a profession – my art is everything to me … but I know it is not the higher life or the right life for a woman. (McCormick 1981:104)

Whilst it may be that Hodgkins remained unmarried out of sexual preference, she also felt it advantageous to her career to remain single; she wrote that she 'must be alone. A woman has no future otherwise.' (McCormick 1981:218). My contention is that, regardless of an individual artist's attitude towards their own sexuality, the issue remains as important as an artist's gender. As viewers, our own sexuality affects our responses to works of art, interacting in unpredictable ways with images we encounter, inflected by the assumptions we make, consciously or not, about the gender and sexuality of the producer(s) of those images.

One of the major studies of Hodgkins' art, by E. H. McCormick, does not discuss her sexuality; he suggests that a group of figure drawings, presumably including *Adoration*, should be seen as an expression of Hodgkins' sentiments on hearing of her mother's death (McCormick 1981:103). Hodgkins' letter describing the 'extraordinary bond between a Mother and child even when you have lived so long apart' (Gill 1993:395) has been seen as further evidence of her concerns when producing the image. Nevertheless, the rest of this letter goes on to show that Hodgkins was thinking of herself in the role of a child, and of the loneliness of going through the rest of life with 'no-one ahead of one in experience – in meeting life'. This does not seem to accord in any simple way with the *Adoration* drawing, which focuses on the feelings of the mother rather than the child, and it seems perverse to ignore the fact, commented on by so many viewers at the Whitworth, that what at first sight appears to be a family group consists of two women and a child. Many visitors wanted to know whether Hodgkins was suggesting that two women, lesbians or not, could raise and care for a child as successfully as a man and a woman. Or whether she saw herself in the role of a child still, protected and cared for by her two friends, Hannah Ritchie and Jane Saunders, who may have modelled for this drawing. Such speculation, based on biographical information available to few of those viewing the drawing when it was first exhibited in 1927, is in some ways irrelevant, but a drawing which focuses on the relationships between two women and a child raises such questions, and viewers will answer them as they can.

The absence of such unconventional possibilities made many visitors feel more at home with John Bratby's drawing. Bratby's work during the mid-1950s was part of a brief

post-war movement away from abstraction and towards realism in art. Many contemporary critics associated realism not only with a particular style but also a certain subject matter, 'familiar unglamorous scenes of everyday domestic life' (*The Times* 1955, quoted in Cherry and Steyn 1982:47). For others, notably John Berger, it was also a social and political matter; realist artists accepted that they had a social responsibility to communicate directly to ordinary people, to make the viewer 'more aware of the meaning and the significance of familiar and ordinary experiences' (Cherry and Steyn 1982:47). Berger's left-wing politics and his espousal of artists such as Bratby linked their work into the larger political situation in Britain during the 1950s, when realism could, within the polarised political situation of the Cold War, be linked with Soviet Socialist Realism, and opposed to the Abstract Expressionism associated with the United States. This atmosphere could give drawings such as *Jean Bending over David* associations which are difficult to recapture forty years later; the aggressive black lines suggesting the harshness and poverty of working-class lives, the basket a substitute for the cot they could not afford.

This situation, however, meant that a group of male painters became associated with domesticity, their studios becoming merged with their domestic lives; indeed, Berger claimed that 'the realist attitude breaks down the studio wall and projects the artist into ordinary life' (Berger 1952, quoted in Cherry and Steyn 1982:00). The artists whose work most interested Berger at the time were all men. For him the significance of the domesticity they depicted lay along the axis of class rather than gender relations; they were championing domesticity not because they were interested in dignifying the lives of women confined to domestic spaces, but because they were attaching new significance to the lives of working-class men. Berger argued strongly against art that appeared to depend too heavily on the indulgent individualism of artists wallowing in their own emotions; instead he championed 'the work of painters who draw their inspiration from a comparatively objective study of the actual world: who inevitably look at a subject through their own personality but who are more concerned with the reality of that subject than with the "reality" of their feelings about it' (Berger 1952, quoted in Cherry and Steyn 1982:47). It was not until some years later that Berger began to acknowledge the way in which the 'reality of that subject' was inevitably filtered through not simply a 'personality' but a gendered identity.

5 The artist's profession

THIS FINAL chapter investigates some of the variety of ways in which women have worked as professional artists and designers, looking in particular at the different kinds of relationships this has involved between women and men working at different stages of the design and production processes involved in the creation of cultural objects.

The professional activity of certain women has long been shadowed by the activities of many others described, and often denigrated, as amateurs. Even today, for every woman working as a professional artist there are numerous others who paint, draw, sew, knit and decorate cakes on an amateur basis. The status of the amateur, however, has not always been so lowly. In eighteenth-century Britain members of the ruling elite, both male and female, saw amateur art production as entirely suited to their elevated social status. However, whereas male members of the ruling class could be seen as contributing to the store of useful knowledge, through drawings and art work related to the surveying of land, to the study of botany or the recording of antiquarian objects, women were encouraged by teachers and sellers of art materials to produce drawings to decorate the home, as a task more fashionable, and more useful, than needlework. Whereas the activities of men in collecting and producing

'[your] daughters ... will become painters. Do you realise what this means? In the upper-class milieu to which you belong, this will be revolutionary, I might almost say catastrophic.'

Joseph Guichard, Berthe Morisot's teacher, to her mother (Morisot 1986:19)

works of art on an amateur basis could be dignified with the label 'connoisseur', the only equivalent term for knowledgeable women – 'bluestocking' – was strongly pejorative.

This subject, perhaps more than that of any other chapter in this book, reflects on pairs of works in other chapters. The example of Maria Cosway in chapter two demonstrated the way in which many men felt that their social standing would be compromised were their wives to earn money by working as artists. In chapter three there is an example of a male amateur paired with a female professional artist, but as the accompanying text makes clear, this apparent reversal reflected changing ideas about the nature of genius in art, and did not effect any fundamental change to the relative values ascribed to their work by contemporary critics. During the nineteenth century femininity was widely regarded as encompassing qualities which were the very antithesis of the professional artist, so that the education of many middle-class women included being taught sufficient skills for amateur practice only; however, by this time, the male equivalent, the amateur gentleman, had already declined significantly in importance.

The pairs in this chapter deal with several different kinds of art practice, including the role, newly developing in the twentieth century, of designer. The allocation of different roles within certain production processes is also considered, with one pair comparing a work designed by a woman and made by men with a work designed by a man and made by a woman. The links between the practice of painters and engravers are also considered, in the context of the consumer boom in eighteenth-century Britain in which all art practice was inevitably involved.

The final pair in this chapter extends the question of how women have worked as professional artists to consider women as viewers. One of the many problems which women in previous centuries encountered in their attempts to work as professional artists was the strength of certain ideas about how, and in what circumstances, it was socially acceptable for women to indulge in the kind of prolonged staring, the intense visual scrutiny, which is essential for an artist wanting to record aspects of the visual world. This was especially difficult for women who wanted to work as portrait painters, since, throughout the eighteenth and into the nineteenth century, for a middle- or upper-class woman to scrutinise the face of a man to whom she was not related was widely considered to break acceptable bounds of propriety. During the nineteenth century, the fashion for women venturing out of doors to wear bonnets with wide flaps either side of the crown both symbolised, and physically enforced, the restraints imposed on women's looking. These flaps narrowed the field of vision of the wearer, enforcing a modestly directed downward gaze whilst at the same time protecting the wearer from the unwanted scrutiny of the gaze of others. Discussion about what was, and what was not, a suitable object for the eyes of women abounded throughout the eighteenth and nineteenth centuries, so that a particular strand of criticism produced in response to the annual exhibitions at the Royal Academy focused on those paintings which were considered to present an affront to the eyes and sensibilities of women visitors.

This brings us finally to consider the situation of women visitors to art galleries today. A recent survey of the visitors to the Whitworth Art Gallery suggested that over 60 per cent of visitors were women. This may not come as any great surprise, since, as Dinah Birch has suggested, 'The arts are perceived as having to do with feeling, with beauty, with complex forms of resistance to the triumph of hard edged law and logic.' (Birch 1992:52). The final pair of objects asks female readers in particular to consider their own experiences as visitors to art galleries, and to ask themselves whether there is any difference between their experience of looking at representations of women by women artists, and the representation of women by male artists. It has been suggested that what distinguishes representations of women by women artists

from those by their male counterparts, is that the gaze or exchange of glances shared by a female artist with another woman, be she sitter, model, friend or relation, is that of equals, whereas the relationship between male artist and female sitter is always one of dominance. Here, once again, readers are asked to decide for themselves whether they think this is so.

Attributed to VANESSA BELL
1879–1961
White VI 1913
Printed linen
Printed in widths of 78.8 cm (31 ins)
Fragment size 51 x 80.5 cm (T.1984.22)

PAUL NASH 1889–1946
Cherry Orchard c.1930
Block printed crêpe de Chine
Repeat size 29 x 28.7 cm
Fragment size 166 x 98 cm (T.11053)

THE DESIGNERS of both these textiles are probably better known for their work as painters. The pair emphasises the way in which gender issues intersect with the problematic evolution of the role of designer in Britain in the early decades of the twentieth century, as artists and craftspeople wrestled with the implications of allying themselves with commerce by working for industrial production. The designs for these two textiles were produced seventeen years apart. The earlier piece is thought to have been designed by Vanessa Bell, and although there is no conclusive evidence for this, the fact that the attribution was first made during Bell's lifetime (in the catalogue to an exhibition organised by the Victoria and Albert Museum in 1955) suggests it is probably correct. Paul Nash, who designed the later piece, was highly critical of both the ideals and the practice of the Omega Workshop within which Bell's work had been produced. What Nash had in common with Bell and Roger Fry, the founder of the Omega Workshop, was a desire to change the way in which domestic products – carpets, textiles and furniture, etc. – were both produced and consumed in early twentieth-century Britain. However, when one looks more closely at the actual conditions in which the two textiles were produced, it becomes clear that, despite the challengingly modern appearance of these abstract and semi-abstract designs, and despite the differing ideals of Nash and Bell, both textiles were produced in circumstances which signally failed to overcome the prejudices which all three saw themselves as crusading against, prejudices founded on notions of difference based not only on gender but also race and social class.

Roger Fry's founding of the Omega Workshop in 1913 was motivated equally by his hatred of contemporary mass-produced domestic furnishings, with their smooth, machine-finish, and by his dislike of the hand-crafted perfectionism of the craft workshops inspired by the ideas of William Morris. Fry had no patience with what he saw as the rural slowness and sententiousness of the Arts and Crafts movement. Instead of producing lasting family heirlooms, the urban and urbane Omega Workshop produced objects to be bought on impulse and replaced as soon as the purchaser tired of them. Fry also rejected Morris' belief that the decoration of an object should be subordinated to its form. All this led Fry to be attracted to African tribal art, whose products he saw as the direct outcome of the vigour and simple joy of their producers. Fry self-consciously contrasted the work of the so called 'savage' with the products of the 'cultured' West, claiming in the preface to the 1914 Omega catalogue that the value and significance of cloth woven by 'the Negro savage' was greater than that of a velvet brocade from a Lyons factory.

Nevertheless, there was some dishonesty

about the way in which Fry tried to slide his idealisation of the working conditions of tribal Africans onto the realities of the class structure of early twentieth-century British society. Although he eulogised the 'primitive joy' of native production, contrasting it with the joylessness of modern factory workers, the conditions of production in Fry's own workshops were not as close to those of the 'Negro savage' as he might have claimed. Most of the artists at Omega worked only as designers, often delegating the actual making of objects to people seen as inferior in terms of both class and gender: working-class women. Whereas Fry felt the tribesman's joy came from his involvement with the entire production process – from design to making and decorating – production tasks at the Omega Workshop were carried out by staff divided into clearly stratified layers. The privileged top layer consisted of artists who produced designs for objects, and who were allowed to work when they felt like it rather than keeping to specified hours. There were two lower strata: the lowest, consisting of professional workshop hands and domestic caretakers, and an intermediary level of more 'artistic' staff and helpers; both consisted almost entirely of working-class people, most of whom were women. The artists did the creative design work, leaving the 'Slade girls', such as Winifred Gill, to interpret their instructions. Even more mundane tasks, such as filling in the cross-stitch backgrounds for chairs covers, were left to women such as Mrs Miles, the caretaker's wife. Thus, despite the inclusion of a few sophisticated women such as Vanessa Bell amongst the privileged group of artists, the Omega project as a whole relied on groups of low status supporting females to keep both the workshop and the showroom afloat.

The example of the Omega Workshop makes clear the importance of considering the full range and complexity of issues, including those of social class, with which gender issues are inflected. Fry's organisation of the workshop had been inspired by the experiments of Paul Poiret's 'Studio Martine' in Paris. Poiret recruited working-class teenage girls with no artistic training in the belief that they could be encouraged freely to express on paper their responses to stimuli such as animal and plant life, and that these impressions could be translated into designs for textiles and pottery. Fry's attraction to the idea of the spontaneity and so-called 'primitive' response to colour and pattern by these women had parallells with his interest in the work of African tribesmen. However, the working-class women who worked for Fry were frequently disparaged: Virginia Woolf characterised an assistant in the showroom as 'a foolish young woman in a Post-Impressionist tunic' (Woolf 1977:7.1.1915). On the other side of the counter, and at the other end of the social scale, were female customers of the highest social status such as Lady Ottoline Morrell and Lady Cunard, who were assiduously courted by Fry in the hope that their interest would make the workshop's products fashionable and desirable. Their patronage was encouraged by flattering gestures such as naming textile designs after favoured patrons: Fry's *Mechtilde* was named after the German ambassadress, Princess Mechtilde Lichnowsky, whilst Vanessa Bell's *Maud* and *White VI* were named after Lady Cunard and Amber Blanco White.

The social stratification which structured the conditions in which the textile *White VI* was produced thus make something of a mockery of Fry's insistence that the designers of textiles should not be credited individually for their work. The fabric *White VI* is simply marked with the name and Ω symbol of the workshop; the attribution of other designs to individual artists has only been made in the last twenty years. Fry wanted the workshop's products to be seen as the work of a community, in the belief that all the best art was communal. However, in reality the conditions of the Omega workshop were far from this ideal, with the privileged status of individual artists, whether men or women, supported by groups of working-class women accorded greatly inferior status.

Paul Nash, the designer of the later of the two textiles discussed here, was caustically critical

of the artists working in the Omega Workshops, who he felt were simply behaving as painters, rather than designers. Nash felt that the Omega artists, not seeing any need to supplement their skills as painters with craft skills, simply painted objects made by other people and then varnished over everything. Nash knew well the strength of the feeling amongst many artists that it was somehow undignified for them to do anything but paint; he spent much of his career encouraging artists to have a higher regard for design work, trying to prove to them that working for commerce did not necessarily entail compromising their artistic integrity. However, despite the dramatic changes in the relationship between art and industry which took place during Nash's lifetime, it remained true that, for the most part, the most privileged positions in the production process were occupied by men. This is certainly true of *Cherry Orchard*. The more prestigious design activity having been carried out by Nash, this fabric was initially both printed and sold by women. Celandine Kennington, usually referred to as 'Mrs Eric Kennington', used Nash's *Cherry Orchard* pattern in some experiments with hand block printing, the success of which encouraged her to set up a larger scale workshop in Hammersmith, known as 'Footprints', as the textiles were initially printed by walking over the blocks. *Cherry Orchard* and several other of Nash's textile designs were sold through a small shop run by a woman, Elspeth Little's 'Modern Textiles' in Beauchamp Place.

However, in spite of his enthusiasm for artists becoming involved with industrial production, Nash's dislike of the commercial habit of producing one fabric design in several different colourways was symptomatic of his lingering desire to cling onto the privileges of the artist. He claimed that a pattern could only ever work in the one set of colours in which it was designed, in the same way that an artist might claim that the colours of a painting could not be altered. This highlights the important ways in which ideas about commercial production were inflected by contemporary gender relations. Nash had a tendency to characterise these commercial imperatives which he fought against as 'masculine'; he held a very low opinion of businessmen, who he saw as constantly trying to lower the standards of production in the interest of commercial gain. The task of the artist was to prevent his vision from being sullied either by the demands of these men or by the taste of the middle-class women who, in *Room and Book*, Nash characterised as the main selectors of domestic furnishings. In such circumstances, designers were treading an uncomfortably narrow path between 'masculine' commercial production and 'feminine' consumption. Once again two qualities represented as opposites – 'business' sense and instinct – have been mapped on to gender difference which is seen as a fundamental dichotomy naturally structuring all human relations.

**Anonymous males after
MARY (MAY) MORRIS** 1862–1938
Arcadia 1886
Wallpaper, colour-printed from wooden blocks
Fragment size 25.5 x 41 cm
Repeat size 26.9 x 39.5 cm (10½ x 15½ ins)
(WA.1184.1967a)

**Anonymous female after
LEWIS FOREMAN DAY** 1845–1910
Narcissi c.1890
Cotton sateen with silk embroidery
75 x 56 cm (T.112.185)

BOTH THE OBJECTS discussed here were produced in the orbit of the Arts and Crafts movement inspired by William Morris and his colleagues. Many of the leading members of this movement, including men such as Walter Crane and William Morris himself, as well as women such as Morris' younger daughter May, were committed socialists, convinced that the revision of the way in which art and craft work was produced in Britain could be part of a larger transformation of the inequalities of British industrial society. However, feminists carrying out research into the movement during the late 1970s and 1980s suggested that the socialist ideals of these men and women did not necessarily include a desire to reform the lot of women. Anthea Callen pointed out that

a movement with often radical social aims, which should have contained the potential for an equally radical reassessment of the personal and practical relations between men and women, turned out to be reactionary in its reinforcement of the traditional patriarchal structure which dominated contemporary society. (Callen 1980:17)

Despite the professed aims of the movement to bring about social change, in particular through changing the lot of working people, there seems to have been no questioning in Morris' immediate circle of the way in which the allocation of different kinds of work was fundamentally divided along gender lines.

In the case of the two objects under comparison here, it is important to realise that what might appear to be a hopeful sign of change, in that the wallpaper is evidence of women being able to work as designers in the late nineteenth century, should not be taken as an indication of any widespread opening up to women of the possibilities of undertaking professional training and work. Instead, May Morris was one of a tiny minority of middle- and upper-class women who, by virtue of their being wives or daughters of artists and craftsmen, were involved in the running of arts and crafts workshops. It is not known whether May Morris was paid for her work; it is, however, certain that there was an enormous gulf between the work of women like Kate Faulkner and herself, who were related to the founders of the Morris Marshall and Faulkner firm, and the unknown numbers of waged women who were employed in the workshops mainly in the one area of work considered suitable for females: embroidery. At the time May Morris' wallpaper was designed, most of the trades connected with the arts still actively prevented the entry of women into their apprenticeships: particularly notorious in this respect were gold and silver smithing and furniture-making. The lot of working-class women remained the same within the Arts and Crafts movement as it did outside: they were acceptable as workers only on the lowest rungs of the craft-linked industries, in areas which required little skill and attracted very low rates of pay.

May Morris' work as a designer of this wallpaper is exceptional in a further sense, in that it was at the time unusual for the designer of a wallpaper, male or female, to be credited by name. In this respect Metford Warner, proprietor of Jeffrey and Company, the sole producers of wallpapers designed by Morris and Co., broke from traditional practice in order to promote his company's products as 'artistic' and differing from the larger bulk of commercially produced wallpapers. Wallpapers such as *Arcadia* were also unusual in being printed by hand from wooden blocks carved in relief, rather than any of the mechanised processes which had been developed since the 1830s. This provides one example of the many ways in which art galleries can, by presenting objects such as wallpapers through display techniques developed for the exhibition of paintings and drawings, give a distorted impression of the way such objects were originally produced and consumed. Wallpaper fragments such as the one discussed here have in the past been shown in picture frames accompanied by labels giving prominence to the designer in the same way as the painter of a picture would be credited. In fact, a surviving log book for Sanderson and Company dating from the early years of the twentieth century demonstrates that designers were by no means the most important people in the production line. A comparison of the recorded costs of paying designers and block cutters shows that the cutting of the wooden blocks was a far more expensive operation. Design fees recorded on one page of the book range from £4 14s 6d to £9 9s, whereas the cost of cutting the blocks could be as high as £22 (Woods 1987, cat. no. 53). Likewise, the business of translating the design into a number of different colourways was just as important as the invention of the original design, and this was usually carried out not by the designer but by men employed within the Sanderson company on terms similar to the block cutters.

In spite of the fact that May Morris was unusual in working as a female designer of wallpapers in late nineteenth-century Britain, it is clear that this situation did not herald any great changes in the established gender relations more usually occurring in the production and consumption of household goods. Since most wallpaper manufacturing companies were not concerned to publicise the names of the designers of their products, most purchasers of such goods would have assumed, if they thought about it at all, that they had been designed by a man. Furthermore, as men were the usual producers, so the consumer market was increasingly dominated by women; surviving advertisements from the late nineteenth century onwards suggest that most manufacturers wanted their products to be designed in ways that would appeal to what they considered to be 'female taste'. As technological advances in the production of items such as wallpapers facilitated the production of increasingly cheaper goods, so the furnishing of a house was seen as a less significant item in the overall household budget, and was accordingly increasingly delegated to women.

The embroidery designed by Lewis Day is a further example of the fact that, in spite of the socialist ideals at the roots of the Arts and Crafts movement, the way in which many of its products were made simply confirmed rather than challenged existing gender divisions. Much of the history of professional embroidery production in Britain suggests that the traditional division between designer and maker almost always took place along gender lines, with men doing the design work and women doing the actual sewing. This arrangement was not substantially challenged by the Arts and Crafts movement. Whilst Edward Burne-Jones, William Morris and Walter Crane all produced designs for embroidery, the needlework was almost always carried out by women, so that, although the only person whose name is recorded on the Gallery's catalogue card for *Narcissi* is that of the male designer, whilst the executor remains anonymous, we can safely assume that she was a woman, possibly Lewis Day's wife.

May Morris had become the head of the embroidery workshop of Morris and Co. in 1885, and in the following years the

production of small panels for cushion covers and fire screens became a financial mainstay of the firm. Initially such pieces were commissioned by, and designed and made up for, specific individual patrons. Soon, however, the company began supplying special designs already traced onto a suitable supporting fabric with a selection of appropriate silks, so that women could produce these pieces on an amateur basis in their leisure time at home. Their popularity soon led to the production of more pieces in the forms of kits; the Whitworth owns several examples of works produced in this way. Something of a challenge to this overwhelming tendency of women to embroider patterns designed for them by men was presented by Ann Macbeth and her students at the Glasgow School of Art, where embroiderers were taught to design their own patterns; it nevertheless remained true that most amateur embroiderers continued to work from ready drawn designs which left only the choice of stitches and the colours of the silks to them, and the very expensive kits produced by Morris and Co. were, in the early years of the twentieth century, succeeded by the more cheaply produced and widely popular hot iron transfers which enabled women to apply designs to the fabric of their choice.

Thus it is clear that, in spite of the apparently divergent ways in which these two objects were produced, one designed by a woman and executed by men, and the other vice versa, the difference is less significant than it might first appear. May Morris' work offered no more real challenge to the traditional gender divisions in the production of such items than embroidery designed by Lewis Day, and the fact that they share a similar aesthetic, in that they consist of stylised flowers drawn with no attempt at realism but instead with an emphatic respect for the flatness of the wall in one case, or the fabric in the other, is not an unexpected contradiction; instead it confirms that they were produced at the same time by men and women who shared certain radical social and aesthetic ideas but who remained unconvinced of the need for the implementation of these ideas to involve any basic change of the place of women in contemporary society.

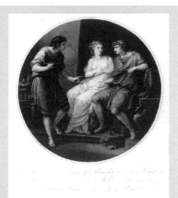

After ANGELICA KAUFFMAN
1741–1807
engraved by Thomas Burke
Alexander Resigning his Mistress
Campaspe to Apelles 1786
Colour-printed etching and stipple
28.5 cm diameter (image size) (P.3636)

After DOMENICHINO 1581–1641
engraved by William Sharp
Lucretia 1784
Line engraving
Sheet size 33.9 x 43.5 cm (P.3308)

THERE ARE a number of apparent similarities between these two prints: both illustrate scenes from classical literature, and the events depicted in both focus on the sexuality of the female protagonists. The major visible difference is that one was printed in black and the other in coloured inks; a further, perhaps less obvious, difference is that the print on the right reproduces the work of a contemporary painter working in Britain, whilst the other reproduces a painting by an Italian painter working in the previous century.

Most modern viewers of these prints will respond to the images without the knowledge of classical history and literature which their publishers would have assumed in their educated male potential purchasers. Kauffman's image relies on a traditional contrast between the powers of war, represented by Alexander the Great, and those of the arts and/or human love, represented here by the celebrated painter Apelles, who has fallen in love with Alexander's mistress whilst painting her portrait. Domenichino's painting also shows the sexuality of a woman being negotiated between two men: having been raped by the son of Tarquin, the Etruscan King of Rome, Lucretia appears here, after telling her husband, in the act of taking her own life. The incident provoked a revolt which drove the foreign kings from Rome, so that Lucretia came to be seen as the embodiment of both Roman virtue and patriotism.

These subjects raise complex questions about sexuality and sexual difference as perceived in the 1990s in works produced in the 1780s. Even if modern viewers were ignorant of the details of Lucretia's story, they might view this image as showing a woman in control of her own fate in a way that Campaspe appears not to be. The question is, of course, whether this leads to the conclusion that such an active female is more likely to have been represented by a woman or a man. The intriguing thing about these prints is that they both contain signs of the way in which professional art practices were gendered in eighteenth-century Britain. These signs, like the subject matter of the images, are no longer widely recognised, but in the eighteenth century they were sufficiently powerful that it can confidently be assumed that contemporary audiences would have had little trouble distinguishing the print reproducing the work of a woman artist.

Educated eighteenth-century viewers would have recognised both images as belonging to a tradition of high art, presenting subjects from literature and history dealing with human and moral issues of the highest import in a suitably elevated style. The work of seventeenth-century Italian painters such as Domenichino were held to be some of the finest examples of such history painting, and, in 1768, a Royal Academy was established in

London in order to encourage the growth of a British school of professional painters who might rival those achievements. The function of such paintings was to address present and future male members of the ruling elite, contributing to their moral development in ways essential to their ability to perform their public duties. Unenfranchised women were deemed to possess neither the capacity nor the need for such intellectual development. History painting was seen to be a masculine style; the President of the Royal Academy, Sir Joshua Reynolds, described it as 'sublime', 'the more manly, noble and dignified manner' (Reynolds 1975:153), as opposed to the 'ornamental' style of painting. This, however, was not the same as being a style practised only by men, as Angelica Kauffman clearly demonstrated. Contemporary critics were ready to admit that certain exceptional women could aspire to this style: 'Miss Kauffman … though a woman, … is possessed of that bold and masculine spirit which aims at the grand and sublime in painting ' (*London Chronicle*, May 1775), but the style remained 'masculine' even though a few women might forsake their own 'feminine' spirit in order to aspire to it.

It is now widely known that although there were two female founder members of the Royal Academy – Angelica Kauffman and Mary Moser – no other women were created Royal Academicians until the early twentieth century. Less well known are the ways in which responses to paintings exhibited at the Royal Academy were affected by the wider circulation of such works in the form of reproductive prints. Prints such as Thomas Burke's after Angelica Kauffman's paintings confirmed the feelings of many critics that, despite her ambition to work in Reynolds' 'sublime' style, Kauffman's work retained aspects of the lesser 'ornamental' or decorative style. This confirmation was provided mainly by the printmaking processes in which Kauffman's work was reproduced. Since the mid-1770s her paintings had been reproduced in the newly-developed stipple process which was seen by contemporary critics and print purchasers alike as being distinct from the older line engraving process in which Domenichino's painting was reproduced.

To begin with, one reason for the popularity of new processes such as stipple with British print publishers was that they offered sound commercial advantages. Stipple plates could be produced more quickly by less highly skilled engravers than the older mezzotint process, and the plates could print more impressions, thus increasing the potential return on the publisher's investment. This should be seen in the context of a developing consumer boom in eighteenth-century Britain which saw a vast increase in both the production and consumption of a wide range of goods, including paintings and prints. However, a conservative discourse increasingly stigmatised the pace of fashionable change which fed the commercial boom as feminine, seductive and dangerous. Publishers of prints such as *Alexander Resigning* were castigated for allowing their production to be governed by commercial rather than artistic considerations. The conflation of commerce, fashion and femininity, overlaid with assumptions about the 'masculine' and 'feminine' nature of the sublime and ornamental styles, encouraged a gendered viewing of printmaking techniques themselves, so that in his 1806 lectures to the British Institution, the engraver John Landseer deplored the stipple process as 'soft and effeminate', and called for a return to the 'manly' style of line engraving which had been practised by Sharp.

Eighteenth-century viewers of these two prints might be assumed to have responded not only to the techniques in which the images were reproduced, but also to the presence of colour in Kauffman's image, and its absence in Sharp's engraving. Engravings such as Sharp's were rarely printed in colours. The promotion of the practice of contemporary painters as a 'liberal' rather than 'mechanick' art involved stressing the intellectual aspects of their activities, such as composition and design, and denigrating those aspects which appealed to sensual rather than intellectual faculties, such as colour. To print the work of a seventeenth-century Italian artist in colour would have

offended the sense of decorum of most serious connoisseurs and critics; to reproduce Angelica Kauffman's work thus merely confirmed an existing tendency to categorise her work as 'decorative'. Such presentation suggested that reproductions of her work should be regarded as 'furniture prints', to be framed and hung on a wall rather than kept in folders or bound into volumes to be studied alongside books in a gentleman's library. This is not to say that the work of certain male artists, such as Richard Cosway, was not also reproduced in this way; only that when conjoined with the work of female artists it appeared to confirm certain attributes which then appeared integral to their feminine natures.

However, one final consideration returns us to the original consumers of such prints. It has been suggested that publishers were deliberately targeting such prints towards female viewers, at a time when rich and fashionable women were beginning to exert greater influence on the design and decoration of their domestic surroundings. As we have seen, the suggestion that these works are 'feminine', and might therefore have appealed to female rather than male purchasers, is more complicated than might at first be apparent. Nevertheless, the painting by Kauffman which was reproduced as a pair to *Alexander Resigning* should make us stop and think: *Cleopatra throwing herself at the Feet of Augustus after the Death of Marc Antony*

also shows a woman with two men in a classical interior. Like Campaspe, Cleopatra appears to be submissive and passive, her fate in the hands of the standing figure of Octavian, the Roman Emperor who had just defeated the combined forces of Antony and Cleopatra at the battle of Actium, and who had thus taken Cleopatra prisoner. Kauffman, however, could have relied on educated members of her audience to know that, rather than submit to the indignity of being displayed as a captive in Octavian's victory parade, Cleopatra took her own life; the woman who in Kauffman's image appears captive and submissive in fact retained control of her own fate. We are left to speculate whether, within the apparent constraints of the gendering of categories of production and reception in late eighteenth-century Britain, Kauffman nevertheless managed to address a positive message to a small number of educated members of her own sex.

(Please note that as the Whitworth does not own a colour-printed impression of the print after Kauffman that includes the inscription, two impressions have been combined in the photograph: one in monochrome, sepia-coloured ink, with the inscription, and a colour-printed version with the inscription cut away.)

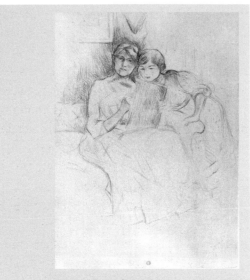

BERTHE MORISOT 1841–95
The Drawing Lesson c.1887
Drypoint
18.8 x 13.7 cm (P.22107)

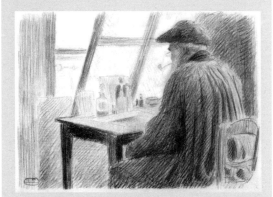

LUCIEN PISSARRO 1863–1944
Camille Pissarro Etching
Chalk, coloured pencil and bodycolour
14.6 x 20.3 cm (D.1946.9)

THESE TWO images both show artists at work. The most obvious difference between them is that the male artist turns his back on us, apparently so absorbed in his work that he is unaware of our presence as viewers, whilst the female artist looks frankly out at us, meeting our gaze directly with her own eyes. Since this latter work is now known as *The Drawing Lesson*, we might deduce that the young girl beside the artist is being taught how to draw what is in front of them. It is therefore slightly disconcerting to realise that what appears to be in front of them is us, as viewers; we are apparently the object of the woman's careful scrutiny, being recorded, it seems, on a sheet of paper attached to the board on her lap. Whereas the title of the other drawing makes it clear that we are looking at a portrait of a father by his son, here we may have some difficulty in deducing the relationship between the artist and the woman depicted. The fact that the artist is female may lead us to suppose, correctly, that the image is a self-portrait. Berthe Morisot has drawn herself, and her daughter Julie, in a mirror. The fact that she appears in the image to be drawing with her right hand, rather than her left as she would appear in a mirror image, is due to the fact that it is a print, and that the process of printing an image reverses the mirror image once more. Given the steep angle of the drawing board and the amount of pressure needed to scratch drypoint lines into a metal plate, it is unlikely that Morisot is

here making her drypoint lines directly onto a copper plate; instead she must be assumed to have transferred her drawing on paper to a copper plate at a later stage. The fact that Morisot's print is a self-portrait, however, forces us to realise that although we now feel it is us she is studying, the artist was originally examining her own features, and those of her daughter, in a mirror, and that in returning her gaze now we, even more disconcertingly, take on a dual role as both viewer and the artist's own reflection.

A further question arises from this: do the characteristics of these late nineteenth-century images of male and female artists at work tell us anything about the organisation of the artists' profession in Britain and France at this time, or about the ways in which the gender of artists might affect their professional work? Unlike many of the women artists whose work is illustrated in this book, Berthe Morisot's work was held in high esteem by her colleagues. Since her death her work has been eclipsed by the art of her male fellow-Impressionists, but she has remained less invisible than many women painters, and the attention paid to her by feminist art historians since the 1980s has made her work even more popular. In their introduction to an edition of Morisot's correspondence, Kathleen Adler and Tamar Garb have argued that the relative ease with which her art has become accepted and admired is due to the fact that it offers no

challenge either to the traditional story of modernism, or to traditional ideas about what women's art should be like. Instead, Morisot can be slotted comfortably into the story of male-dominated avant garde art merely as 'an exception', in that she was an unusually successful woman painter (Morisot 1986). This can be done without any more fundamental questioning of the methods by which certain qualities came to be celebrated as modernist, and through which, with some notable exceptions such as Morisot, the majority of women's creative work has been ignored.

This is not to say that Morisot's gender did not cause difficulties in her life as a professional artist. To begin with, the mere fact of a woman of her haute-bourgeois social background becoming a professional challenged social conventions; Morisot's brother recalled later in life (possibly with some dramatisation) that the artist employed to teach her and her sister Edma warned their mother:

Considering the character of your daughters my teaching will not endow them with minor drawing room accomplishments; they will become painters. Do you realise what this means? In the upper-class milieu to which you belong, this will be revolutionary, I might almost say catastrophic. (Morisot 1986:19)

Furthermore, it is clear that her male colleagues were more used to relating to women as models rather than fellow painters; indeed, Morisot herself spent a great deal of time modelling. Since male artists cemented many of their professional relationships and developed ideas about art in Parisian cafés from which her class and gender excluded Morisot, she was further distanced from her colleagues.

The unusual fact of Morisot having managed to work within these restraints was explained by many of her contemporaries by the fact that her art was a natural outpouring of her femininity. Her brushstrokes, her pale colours and her choice of subject matter were all seen as peculiarly appropriate to a woman painter; indeed, a woman painter, if she remained true to herself, could, it was implied, paint in no other way. Critics of Impressionism further contended that the style within which Morisot chose to work was concerned only with recording the superficial aspects of visual appearances, and so was especially appropriate for women artists who had long been considered incapable of penetrating beneath the surface of things (and the sexual echoes of the language here is surely not coincidental). Women had long been advised to restrict themselves to painting still lives and genre scenes which appeared to require less in the way of education and training, so that for Morisot to confine her subject matter for the most part to domestic scenes featuring her mother, her sisters and their children, was likewise thought especially appropriate to her status as a woman painter (Morisot 1986:7).

It is not difficult to refute these assumptions. The brush work characteristic of a certain stage of Impressionism was shared by male as well as female painters, and had more to do with the intention of avant garde artists to move away from the academic emphasis on highly finished paint surfaces than with the gender of the painter. Likewise, the widespread suggestion that Morisot's art was instinctive, that it was somehow essential to her femininity, so that she could not help painting those she loved, is contradicted by the evidence of many of her letters which suggest she frequently found the process of painting agonisingly difficult. The picture of Morisot presented by these letters has to be treated with caution; selected and edited by her grandson, they of course present a particular picture of the artist which it would be dangerous to regard as more authentic than any other. Nevertheless, they do suggest Morisot's continual self-scrutiny, plagued not only by self-doubt but by ideas about what her gender was capable of.

The comparison between these two works highlights the intense self-scrutiny suggested by Morisot's print. Lucien Pissarro retained an interest in the exploration of the effects of light instigated by his father's colleagues. In many ways the subject of his drawing is the effect of light as it is filtered through the special window screen many printmakers used to diffuse the harshness of direct sunlight; the

window, screen, bottle and plates draw our attention just as much as the figure of Pissarro himself, about whom we learn little other than his total absorption in his task. By contrast, Morisot pays little attention to the contents of the room. The rich blackness of her drypoint lines focus our attention on the heads of the two women as they stare into the mirror, the traditional accompaniment of the allegorical female figure representing *Vanitas*, an over concern with the fleeting things of this world. Women's relationships with their own appearance formed a continuing theme of Morisot's art. Her first exhibited figure painting showed a lightly draped female figure lying on the bank of a river and staring down at her reflection in the water. Later works show women getting dressed to go out in the evening, the process of putting on a public appearance which is checked before a mirror. Such subjects were by no means unique to women painters; Manet and Degas were also observers of this process, but there is a distinct difference between Manet's flirtatious *Nana*, sure of her ability to attract the male viewer at whom her glance is directed, and Morisot's *The Cheval Glass*, before which an uncertain young woman stands, her head hung down, looking distrustfully at her reflection rather than acknowledging any viewer (Stuckley and Scott 1987, plates 49 and 50).

The critical self-examination which went into *The Drawing Lesson* can by extension be linked to the ways in which both Morisot and her sister were careful not to present too radical a challenge to the social or artistic conventions which marked the boundaries of acceptable behaviour for their gender. When painting a portrait of her pregnant sister, for example, Morisot was careful not to draw attention to her swollen shape in a way that her contemporaries would have found unseemly. She also adopted her conventional attitudes of her class towards raising her daughter, who was fed by a wet-nurse. Nevertheless, foolish though it may be to attempt to present Morisot as a proto-feminist, the effect of her drypoint remains challenging for both male and female viewers alike. The frankness and openness of the gaze which meets our eyes, without a trace of sexual overtones, is rare in Western art; female viewers have grown accustomed to the necessity of positioning themselves in relation to the ideal male viewer who is addressed by the majority of female figures in Western art. Here female viewers have the opportunity not only to imagine themselves being drawn, but also doing the drawing; at once the artist and the sitter, an experience which may be as enjoyable and unsettling as it remains rare.

Conclusion

ALMOST BY definition a book of this nature cannot be exhaustive, and will leave many further avenues to be explored. There are whole genres of painting at the Whitworth Art Gallery, such as portraits and landscapes, which this book has hardly begun to consider, and likewise there are whole areas of production not represented at all at the Whitworth. It is possible, however, to see this in a positive light: one of the main aims of this book, as well as of the *Women and Men* exhibition, is to suggest a method of asking questions, a particular type of analysis, rather than exhaustively to apply this method. As much as anything, I hope that it will encourage further looking, further analysis and questioning of works of art, rather than presenting the issues as an open and shut case. The most important thing I hope the book has achieved is to demonstrate that the question 'Which is by a woman?' is an important and significant one; anyone who came to the exhibition, or opened this book, with the instinctive feeling that great works of art should be studied and enjoyed on a level which makes the gender of the producer irrelevant has, I hope, been given cause to re-examine their feelings.

Museums of women's art

It seems appropriate to conclude with further thoughts about museums devoted to women's art, since the issues surrounding such projects draw together so many of the themes discussed in this book. In the early 1980s a heated controversy began in North America over the proposed founding, in Washington, of a National Museum of Women in the Arts. The controversy did not abate when the Museum opened in 1987. As Anne Higonnet has described, the institution prompted a number of important questions, ranging from 'Were women being hailed or condemned by a sex-segregated institution?' to 'Had too many compromises been made to fund the museum?' (Higonnet 1994:250). Higonnet concludes that although, on the surface, it seemed to be the issue of gender that was causing the controversy, in fact it was other issues which the project also exposed, to do with class and culture, that fuelled the debate:

The NMWA attracted so much attention because it threatened to lay bare the assumptions on which most art museums operate. The art museum democratically asserts high art as a common cultural heritage, and such is the mediated prestige of high art that we are lulled into credulity. In fact, the art museum is an upper middle class institution supported by corporate funding and women's volunteer labour that genuinely intends to use its power in an attempt to share its benefits – but to what end? The propagation of its own values. (Higonnet 1994: 261–2)

In terms of raising support, financial and moral, the NMWA was enormously successful: large corporations made substantial donations, whilst, at the other end of the scale, 55,000 individuals became members, contributing on average $25 each even before the museum opened, and a further 29,000 followed in the 18 months following the opening. The problem was that the main impetus driving the museum's founder, Wilhelmina Holladay, appeared to be the raising of funding for the museum, whilst other issues, such as the employment of professional staff, appeared to be ignored. Many feminists found Holladay's methods objectionable; Linda Nochlin complained that

Mrs. Holladay is using the goodwill of the women's movement for a project that is totally apart from the goals and spirit of progressive feminism. This museum, instead of being for the people and run by competent professionals, ... is a social battlefield and pleasuring ground for the socially prominent. (Day 1986:115)

As Higonnet argues, although Holladay had wanted the NMWA to be seen as moderate and apolitical, the institution itself demonstrated that it was no longer possible for the issue of gender to be politically neutral. In the end, however, we can only ask whether any real alternative to the NMWA's methods currently exists; Anne Higonnet concludes that

the NMWA represents feminism at its most opportunistic, compromising, and – materially – effective. It makes painfully apparent a discrepancy between feminist ideals and the concrete possibilities for acting on them. (Higonnet 1994:262)

It is useful to bear this in mind when considering the London-based Museum of Women's Art, founded by Belinda Harding and Monica Petzel, who have, since 1992, been working towards the provision of a permanent institution devoted to the viewing, study and research of women's art. They have said that their proposals were mainly stimulated by their sense of a lack of permanence to contemporary initiatives promoting women's art, and by their frustration at the numbers of works by women artists which still remained 'in the vaults' of both national and regional museums, rather than on their walls. During the early stages of the MWA initiative, a survey of six national and regional galleries revealed that out of a total of 29,646 paintings in their collections, only 1,562 were by women, and of these only 84 works were on display. Encouraged by positive responses from British galleries, the MWA plans, once established on a permanent site, to display works by women artists on long-term loan from public collections such as those at the Tate. These will occupy one of its two main gallery spaces, the other being used for temporary exhibitions which will explore a range of relevant issues and which will be used, where appropriate, to show art by men as well as women. The Museum does, however, have other important purposes other

than that of exhibiting: its primary purpose is educational, and it has already organised many events and activities with this in mind, such as the one day symposium which accompanied its launch exhibition in 1994, *Reclaiming the Madonna: Artists as Mothers* (the exhibition was organised by Janita Elton at the Usher Gallery). Its permanent site, once established, will also contain a study centre with facilities including slides, books and computer resources.

When I began writing this book I felt ambivalent about the whole notion of a museum for women's art. It seemed to me that it could so easily become a way of sidelining, and eventually ignoring, art by women, and that the borrowing of works from the vaults of other galleries would merely siphon off work by women from what would still be seen as mainstream art, displayed at other galleries, which would remain overwhelming dominated by work by men. Another fear was that it would be a way for curators at established galleries to salve their consciences by feeling that the existence of such a museum absolved them from the duty to think about how they should address the problem of gender, since it appeared to have been taken out of their hands. I have continued to think over these issues, both in the course of writing this book, and in discussions with students taking the Courtauld Institute's MA in Art Museum Studies. Many of the students to whom I set the task of

writing an essay entitled 'Does this country need a museum of women's art?' came to the conclusion that such a project should not be necessary, but in present circumstances there was probably no better practicable solution. Many agreed with Marina Warner's comment that 'It's a shame in a way that there has to be a Museum of Women's Art – it shows that there's still a problem …' (Morrison 1994:20). Several students also had reservations about the associations of the word 'museum', and wondered whether it was advisable to question or re-think art history through an institutional format so laden with masculine associations. Some were also worried that the mere existence of a museum of women's art would imply that there was such a unitary category 'women's art', rather than an enormous range of diverse works of art by women. In the end, however, I think most of us agreed with Marina Warner's further comment that

museums that are self-defined in some way (that specialise in tapestry, say) are the way we are moving. Its a reaction against the aesthetic school of hanging, and is a response to a public which is saying 'Help us understand. Teach us how to look'. (Morrison 1994:20)

Warner's comment in many ways accords with my aims both in curating the *Women and Men* exhibition and in writing this book, and although I remain ambivalent about the notion of a museum of women's art, I have found no more eloquent argument in its

favour than that put forward by Griselda Pollock at the symposium mentioned above, which accompanied the MWA's launch exhibition. Pollock said that the reason she would now, in 1994, argue for a women's museum more strongly than she would have done twenty years ago, is that

We have discovered in listening to women so much of the profound variety and complexity of women's experience … we need the space with that dedication to listen to this multiplicity … we need to listen to everybody's stories. (MWA 1994:37)

A museum of women's art could not do better than aspire to provide just such a space for listening.

Glossary

Bodycolour
Watercolour that has been mixed with white pigment to make it opaque.

Chalk
Chalk can be made from naturally occurring minerals, such as calcium carbonate, a variety of white chalk. Synthetic chalks (sometimes called 'pastels') can be made from almost any dry pigment mixed with a binding medium such as gum arabic, and then formed into sticks and allowed to dry.

Coloured pencil
Usually referred to as 'crayons', coloured pencils are manufactured like graphite pencils, using coloured pigment instead of graphite. The term 'crayon' can cause confusion as it has been used to refer to a number of different drawing media in the past; the word 'coloured pencil' has therefore been used here instead.

Drypoint
A sharpened needle point is used to scratch lines into a metal (usually copper) plate. When inked and printed as for *engravings*, the 'burr', or rough pieces of metal, thrown up by the scratching, prints a rich, soft, smudgy line.

Earthenware
Pottery made from clay fired in a low-temperature kiln.

Embroidery
Decoration with needlework.

Engraving

Engraved lines are incised into metal (usually copper) plates with a sharp tool, v-shaped in cross section. Prints can be taken from engraved plates by pressing ink into the incised lines and wiping the raised surface of the plate clean; a sheet of dampened paper is then placed over the inked plate and both are run through a roller press under great pressure.

Etching

Etched lines are prepared by the action of acid, rather than cut by hand as for engraving. The plate is prepared with a layer of waxy 'ground', which is impervious to acid. The design is drawn in the ground with a sharp metal point, revealing lines of metal underneath. If the plate is immersed in acid these lines will be 'bitten' into the metal. Once the ground is removed the plate can be inked and printed as for *engraving*.

Mezzotint

A method of printing tones using dots rather than lines. A metal plate is prepared with a special tool (a mezzotint 'rocker') which will pit the surface with tiny indentations. These will hold ink and print a rich black. An image can be created by smoothing away selected areas which will hold less ink, thus producing pale or white highlights.

Pencil

Invented in the eighteenth century, pencils are made from crushed and purified graphite (a naturally occurring form of carbon). The graphite powder can be compressed and inserted into hollow wooden rods. Prior to the eighteenth century, natural graphite was used either in a lump, or a stick, sharpened at one end and set into a metal holder known as a *porte-crayon*.

Relief etching

The lines of the design are drawn onto a metal plate in an acid-resistant medium; the background is then etched away, leaving the lines standing in relief. This is diametrically opposite to the traditional etching method, where the ink-bearing lines are incised into the metal.

Screen print

A variety of stencil printing. The 'screen' consists of a fine fabric stretched over a wooden frame. Stencils can be attached in two main ways: either by blocking out certain areas by painting in a medium which will harden when dry, or by attaching stencils, cut from paper, card or plastic, to it. Ink is forced through the screen onto a sheet of paper below with a flexible blade known as a 'squeegee'.

Soft ground etching

A method of printing soft, smudgy lines which look very like pencil. A sheet of paper is laid over a plate prepared with a soft etching ground. The design is drawn onto the paper so that the pressure of the pencil will cause the wax to stick to the underside of the sheet. When the sheet is peeled away, lines of wax will be removed in areas precisely corresponding to the drawing. These can be etched and then printed as for *engraving*.

Stipple

A variety of etching in which the image is built up from dots rather than lines. A sharp metal point is used to prick dots through an etching ground, which are then 'bitten' as for *etching*. Etched lines can be used to supplement the dotted areas.

Stump work

A method of embroidery using padding to bring certain areas into low relief.

Tapestry

A thick fabric created by weaving coloured threads into patterns or designs; so-called 'tapestry kits', commonly sold in shops today, with coloured wools to be sewn onto a piece of printed canvas are, strictly speaking, embroidery kits.

Watercolour

Watercolour can be made from any pigment ground in water and gum arabic; its distinguishing characteristic is that it is transparent, so that the white of the paper can be seen through it.

Woodcut

A method of printing from wooden blocks in which the lines or shapes to be printed are left standing in relief; other areas of the block are cut away with a knife.

References

Dates in square brackets indicate the date the work was first published.

BARTHES, R. (1977), The Death of the Author [1968], trans. S. Heath, *Image, Music, Text*, London, Fontana.

BATTERSBY, C. (1989), *Gender and Genius: Towards a Feminist Aesthetics*, London, The Women's Press.

BEETLES, C. (1989), *Hercules Brabazon Brabazon 1821–1906*, London, Chris Beetles Ltd. (unpaginated).

BERGER, J. (1952), *Looking Forward*, London, Whitechapel Art Gallery.

BIRCH, D. (1992) Gender and Genre, in F. Bonner, L. Goodman, R. Allen, L. Jameson and C. King (eds), *Imagining Women: Cultural Representations and Gender*, Cambridge, Polity Press.

BOURDIEU, P. and A. DARBEL (1991), *The Love of Art: European Art Museums and their Public*, trans. C. Beattie and N. Merriman, London, Polity Press.

BURGESS, A. (1988), *Little Wilson and Big God, Being the First Part of the Confessions of Anthony Burgess* [1987], London, Penguin.

BUTLER, R. (1962), *Creative Development: Five Lectures to Art Students*, London, Routlege & Kegan Paul.

CALLEN, A. (1980), *Women in the Arts and Crafts Movement 1870–1914* [1979], London, Astragal Books.

CASSON, S. (1933), *Artists at Work*, London, Harrap.

CHADWICK, W. (1990), *Women, Art, and Society*, London, Thames and Hudson.

CHERRY, D. (1987), *Painting Women: Victorian Women Artists*, Rochdale, Rochdale Art Gallery.

CHERRY, D. (1993), *Painting Women: Victorian Women Artists*, London and New York, Routledge.

CHERRY, D. and J. STEYN (1982), The Moment of Realism: 1952–1956, *Art Scribe*, 35: 44–9.

CLARK, K. (1956), *The Nude: A Study of Ideal Art*, London, John Murray.

COMINI, A. (1982), Gender or Genius? The Women Artists of German Expressionism, in N. Broude and M. D. Garrard (eds), *Feminism and Art History: Questioning the Litany*, New York, Harper & Row.

COOPER, E. (1986), *The Sexual Perspective: Homosexuality and Art in the Last One Hundred Years in the West*, London and New York, Routledge & Kegan Paul.

CORK, R. (1988), An Art of the Open Air: Moore's Major Public Sculpture, in S. Compton, R. Cork and P. Fuller (eds), *Henry Moore*, London, Royal Academy of Arts.

CURTIS, P. and A. G. WILKINSON (eds) (1994), *Barbara Hepworth: A Retrospective*, Liverpool, Tate Gallery, and Art Gallery of Ontario.

DAY, S. (1986), A Museum for Women, *Art News*, 85: 6.

DEEPWELL, K. (ed) (1994), *New Feminist Art Criticism: Critical Strategies*, Manchester and New York, Manchester University Press.

DUNCAN, C. (1993), *The Aesthetics of Power: Essays in Critical Art History*, Cambridge, Cambridge University Press.

DUNCAN, C. (1995), Review of K. Deepwell (ed.), New Feminist Art Criticism: Critical Strategies, *Tate*, 7:75.

EPSTEIN, J. (1963), *Epstein: An Autobiography*, ed. R. Buckle, London, Vista Books.

FOUCAULT, M. (1986), What is an Author? [1969], trans in P. Rabinow (ed.), *The Foucault Reader*, Harmondsworth, Peregrine.

FRINK, E. (1990), *Elizabeth Frink: Sculpture and Drawings 1950–1990*, Washington, National Museum of Women in the Arts.

FRY, R. (1972), *The Letters of Roger Fry*, 2, 1913–1934, ed. D. Sutton, London, Chatto & Windus.

GIBSON, R. (1991), *John Bratby Portraits*, London, National Portrait Gallery.

GILL, L. (ed.) (1993), *The Letters of Frances Hodgkins*, Auckland, Auckland University Press.

GREER, G. (1979) *The Obstacle Race: The Fortunes of Women Painters and their Work*, London, Weidenfeld & Nicholson.

GREER, G. (1991), *Paula Rego: Tales from the National Gallery*, London, National Gallery.

HARRIS, J. (1988), Hannah Smith's Embroidered Casket, *The Antique Collector*, July, 49–55.

HARRIS, J. and P. BARNETT (1988), *The Subversive Stitch*, Manchester, Whitworth Art Gallery and Cornerhouse.

HEPWORTH, B. (1977), *Barbara Hepworth: A Pictorial Autobiography* [1970], London, Moonraker Press.

HEWISON, R. (1996), *Ruskin and Oxford: The Art of Education*, Oxford, Clarendon Press.

HIGONNET, A. (1994) The National Museum of Women in the Arts, in D. J. Sherman and I. Rogoff (eds), *Museum Culture: Histories, Discourses, Spectacles*, London, Routledge.

KENT, S. (1985), introduction to *Elizabeth Frink, Sculpture and Drawings 1952–1984*, London, Royal Academy of Arts.

KENT, S. and J. MORREAU (eds) (1990), *Women's Images of Men* [1985], London, Pandora.

KINGSTON, A. (1990), *Mothers*, Birmingham, Ikon Gallery.

LANGDALE, C. and D. F. JENKINS (1985), *Gwen John: An Interior Life*, London, Phaidon Press and Barbican Art Gallery.

LLOYD, S. (1995), *Richard & Maria Cosway: Regency Artists of Taste and Fashion*, Edinburgh, Scottish National Portrait Gallery.

LOWES, E. L. (1908), *Chats on Old Needlework and Lace*, London, Fisher Unwin.

LUCIE-SMITH, E. (1994), *Frink: A Portrait*, London, Art Books International.

McCORMICK, E. H. (1981), *Portrait of Frances Hodgkins*, Auckland, Auckland University Press.

MONTHLY MAGAZINE (1801), Retrospect of the Fine Arts, *The Monthly Magazine*, December, 141–2.

MOORE, H. and J. HEDGECOE (1986), *Henry Moore: My Ideas, Inspiration and Life as an Artist*, London, Ebury Press.

MORE, H. (1799) *Strictures on the Modern System of Female Education*, London, Cadell & Davies.

MORISOT, B. (1986), *The Correspondence of Berthe Morisot*, ed. D. Rouart [1953], introduction and notes by K. Adler and T. Garb, London, Camden Press.

MORRISON, B. (1994), Buried Treasure?, *The Independent on Sunday*, 3 July, 18–20.

MWA (1994), Typescript of the proceedings of a symposium organised by the Museum of Women's Art on Motherhood and Creativity, London, 3 July.

NASH, P. (1932), *The Week End Review*, 19 November, 613

NEAD, L. (1988), *Myths of Sexuality*, Oxford, Blackwell.

NEAD, L. (1992), *The Female Nude: Art, Obscenity and Sexuality*, London and New York, Routledge.

NOCHLIN, L. (1991), *Women, Art, and Power and Other Essays* [1989], London, Thames & Hudson.

PARKER, R. (1984), *The Subversive Stitch: Embroidery and the Making of the Feminine*, London, The Women's Press.

PARKER, R. and G. POLLOCK (1986), *Old Mistresses: Women, Art and Ideology* [1981], London, Pandora Press.

POINTON, M. (1990), *Naked Authority: The Body in Western Painting 1830–1908*, Cambridge, Cambridge University Press.

POLLOCK, G. (1987), *A Feminist Looks Round the City Art Gallery*, Manchester, Manchester City Art Gallery.

POLLOCK, G. (1988), *Vision and Difference: Femininity, Feminism and the Histories of Art*, London, Routledge.

REYNOLDS, R. R. (ed.) (1975), *Sir Joshua Reynolds: Discourses on Art*, New Haven and London, Yale University Press.

ROBERT-BLUNN, J. (1991), Sexism Rules OK, *Manchester Evening News*, 5 December, 32.

RUSKIN, E. T. and A. WEDDERBURN (eds) (1903–12), *The Works of John Ruskin*, London, Library Edition.

SAUNDERS, G. (1989), *The Nude: A New Perspective*, London, Victoria and Albert Museum.

SIMMONS, R. (1991), Howard Hodgkin: New Hand-coloured Prints, *Printmaking Today*, 2:7–8.

SMITH, G. and S. HYDE (1989), *Walter Crane: Artist, Designer and Socialist*, London, Lund Humphries.

STEPHENSON, A. (1992), *Visualising Masculinities* (exhibition leaflet), London, Tate Gallery.

STOKES, A. (1933), *The Spectator*, 3 November.

STUCKLEY, C. F. and W. P. SCOTT (1987), *Berthe Morisot: Impressionist*, Washington, National Gallery of Art.

SULTER, M. (1991), *Echo: Works by Women Artists 1850–1940*, Liverpool, Tate Gallery.

SUMNER, A. (1989), *Ruskin and the English Watercolour: From Turner to the Pre-Raphaelites*, Manchester, Whitworth Art Gallery.

THOMSON, A. (1991), Painting by Genders, *The Times*, 11 December.

WARNER, M. (1996), *Monuments and Maidens: The Allegory of the Female Form* [1985] , London, Vintage.

WASSYNG ROWORTH, W. (1992), *Angelica Kauffman: A Continental Artist in Georgian England*, Brighton, The Royal Pavilion, Art Gallery and Museums; London, Reaktion Books.

WEIL, A. (1986), *Hercules Brabazon Brabazon (1821–1906) and the New English Art Club*, London, Chris Beetles Ltd.

WHITWORTH ART GALLERY (1989), *The Whitworth Art Gallery: The First Hundred Years*, Manchester, Whitworth Art Gallery.

WILENSKI, R. H. (1929), *An Introduction to Dutch Art*, London, Faber & Gwyer Ltd.

WILLIAMSON, G. C. (1897), *Richard Cosway RA and his Wife and Pupils: Miniaturists of the Eighteenth Century*, London, Bell.

WOODS, C. (ed.) (1987), *Sanderson 1860–1985*, London, Arthur Sanderson & Sons Ltd.

WOOLF, V. (1977), *The Diary of Virginia Woolf*, 1, 1915–1919, ed. A. O. Bell, London, Hogarth.